Sam Gardener

PHOTOGRAPHERS AND THEIR IMAGES

FI McGHEE INTRODUCTION BY YOUSUF KARSH

PHOTOGRAPHERS AND THEIR IMAGES

THE WORLD'S LEADING PHOTOGRAPHERS SELECT THEIR FAVOURITE PHOTOGRAPH

CONRAN OCTOPUS

To My Favourite Photographer

First published in 1988 by
Conran Octopus Limited
37 Shelton Street
London WC2H 9HN

Art Editor Trevor Vincent
House Editor Joanna Bradshaw
Editor and Contributor Richard Ehrlich
Production Michel Blake

British Library Cataloguing in Publication Data
Photographers and their images.
 1. Photography, 1950—
 I. McGhee, F.
 779'.09'04

ISBN 1—85029—148—9 (cloth) ; 1—85029—192—6 (paper)

Publisher's Note:
The texts, titles and dates accompanying the photographs are based on
questionnaires submitted to each of the photographers. They were asked to
explain the circumstances in which the photograph was taken, their reasons
for taking it, and the reasons they considered it their favourite.
The photographers' responses have been presented as faithfully as possible,
and in some cases the photographers have preferred not to comment on their choice.

Typeset by Elite Typesetting Techniques, Southampton
Printed and bound in Italy

CONTENTS

FOREWORD

Even though black and white photography has been around a lot longer than colour photography and perhaps does not have the fresh appeal of youth, it can be both exciting and invigorating. The proceeding pages of this book show a gift of talent by Fi that embodies the excitement of creative achievement. We have all had the opportunity to photograph in our own personal style, but sometimes a change of flavour enables us to enjoy one particular picture over another.

All these Masters of Photography have their individual flavours.

CORNEL LUCAS

INTRODUCTION

"We recognize an artist by the background in his pictures, made apparent through depth of focus and atmosphere, and we recognize each other in friendship and love by the same background — the background of light." Thus Edouard Boubat describes his favourite photograph. And, against this ever-present "background of light," Fi McGhee has brought a fresh open curiosity to her diverse portraits in this book.

Meeting with young photographers is always a particular pleasure for me. I met Fi McGhee half-way into her self-imposed globetrotting odyssey of portraying her notable colleagues. Working in often unfamiliar settings, establishing rapport with her sitters, she has provided us not only with sensitive glimpses into the photographers' personalities, but has managed to capture intimations of their own individual favourites — the spirit of their inner environment.

The pictorial choices of the photographers, together with their comments, provide the extra dimension to this book. I was struck by how often the choices were personal, "commissioned by myself to myself," as Jeanloup Sieff writes, or, as John Phillips explains, "because it exemplifies most of the things I like in life." It matters not whether the images fall into the environmental, portrait, fashion, or landscape category; each is suffused with the interior world of its creator. In asking each photographer to choose, comment, and become a subject of her camera, Fi McGhee has illustrated the creative process at work.

YOUSUF KARSH

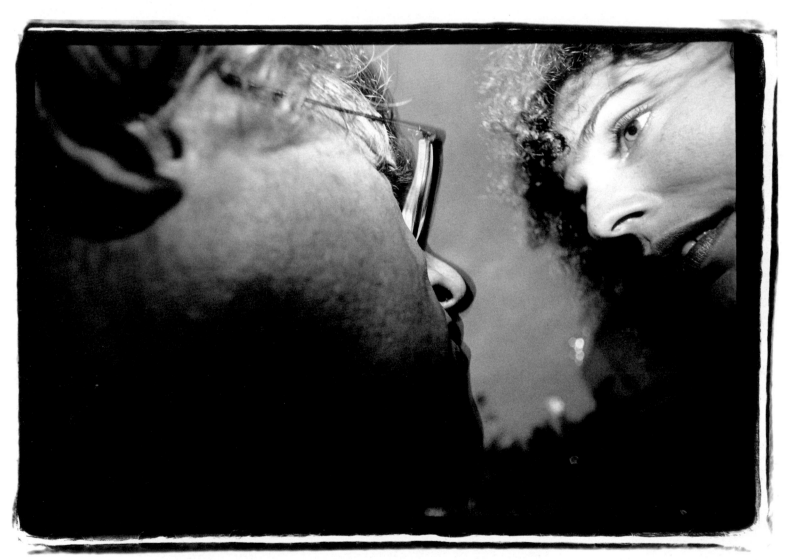

ART AND LAURENCE 1987

"I like this picture because it's my latest and because it represents an extreme departure from anything I've done before. My wife and I were on our motorbike, and I just put the camera behind my head and pushed the shutter release. I would never have composed a picture this way under normal circumstances. I relinquished control and consequently found a new vision, letting the camera find its own way."

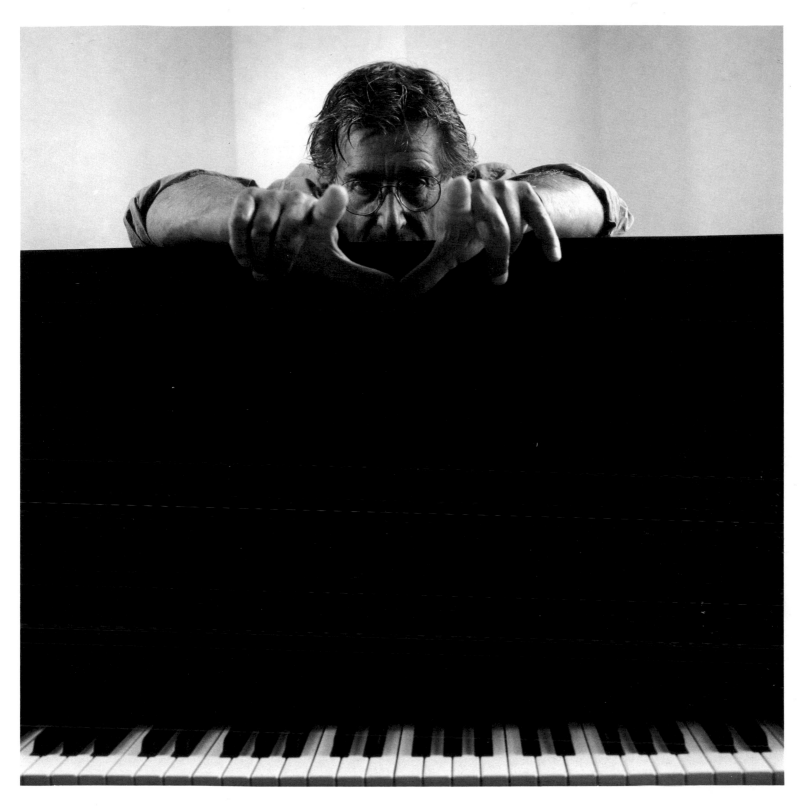

ART KANE

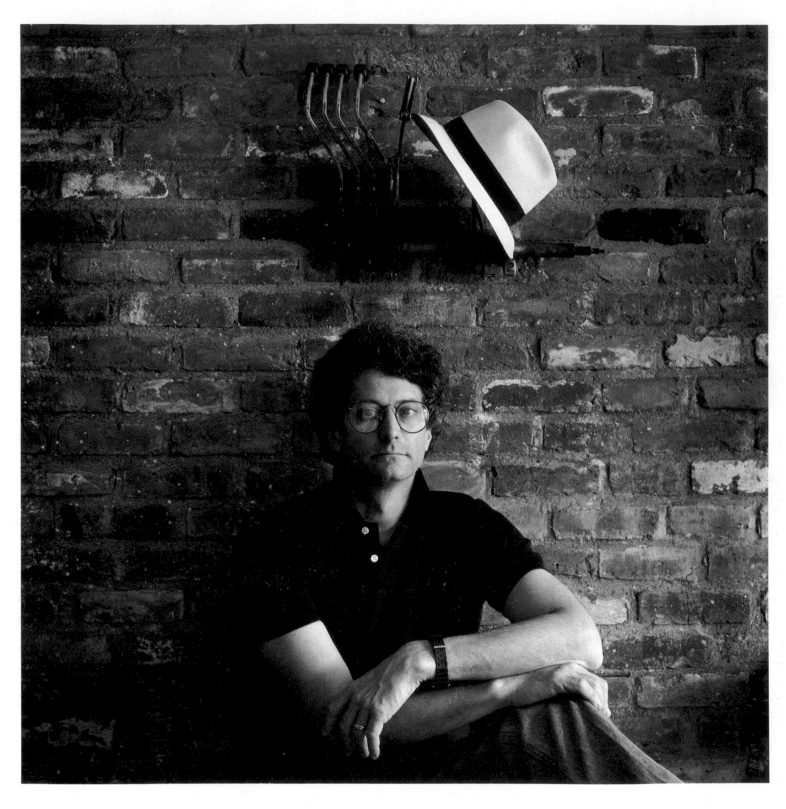

DAVID BURNETT

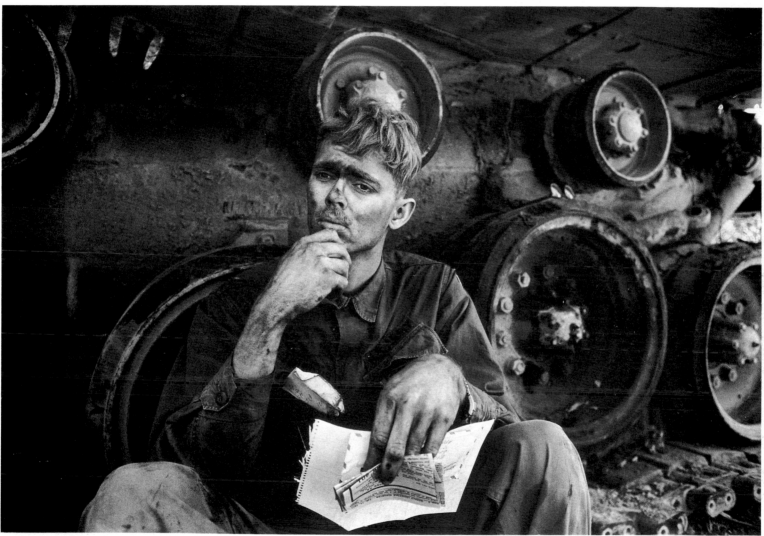

FATIGUED GI AT LANG VEI 1971

"This photograph was taken on assignment for *Time* magazine during the final days of the South Vietnamese/US incursion into Laos in April 1971, a time of greater and greater losses. From the two years I spent in Vietnam, this picture emerges as a moment of quiet fatigue amid the noise and chaos of battle. I don't know how quiet it really was, since the planes were dropping bombs just a few hundred yards away. But it seemed quite quiet at the time, and this young soldier reading a letter from home just drew me to him. I felt that his face reflected the frustration of those days — and the difficulty of trying to stay on top when things aren't going your way.

"It is perhaps a little too obvious — the soldier reading a letter from home — but this soldier was a tank repairman, and they had had a very busy day indeed. I think I know how he felt to have that letter at a time like this.

"I made a few pictures in rapid succession. Looking back, I wish I hadn't used such a wide-angle lens (24mm), but that is how we learn about our pictures. By taking them."

BERT STERN

"I've chosen this photograph because of the Picasso-like head of Mel Ferrer peering in from the left. The sitting took place at the Hotel Crillon in Paris, while photographing the French collections for American *Vogue*. Audrey Hepburn is wearing a Givenchy dress. Instead of a conventional studio, we constructed our own in a large suite at the hotel."

16

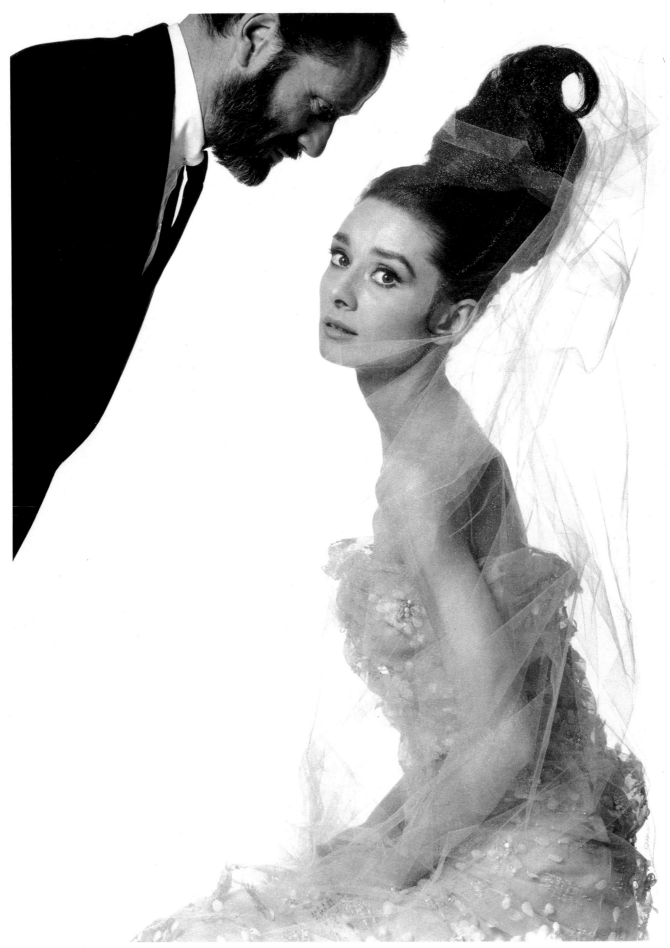

AUDREY HEPBURN AND MEL FERRER 1968

DAME SYBIL THORNDIKE 1970

"I took this picture just before Dame Sybil's death. It was the first time I had used my Hasselblad; up until then I had only used a 35mm camera.

"I developed the films all night, in my converted garden hut darkroom, in the Surrey countryside, and must have used at least six boxes of paper until I got what I wanted, by which time dawn was breaking.

"I emerged into the bright morning light carrying the dripping wet print, so sharp and glistening in the morning sun. The look in her eyes was like the sphinx staring into infinity. When I took the photograph she had been telling me how much she loved her husband who had just died, and every time I see this picture I vividly recall all these memories."

CLIVE ARROWSMITH

EDOUARD BOUBAT

20

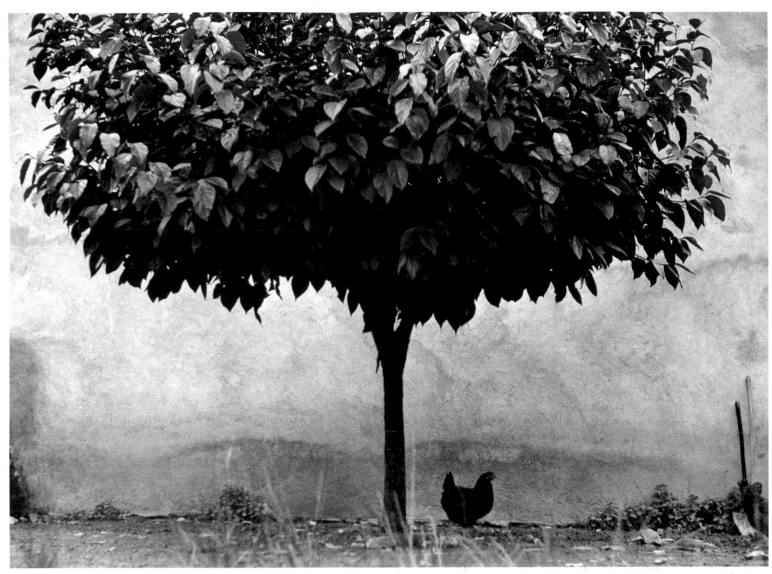

THE TREE AND THE HEN 1950

"In fact, my favourite picture is always my last picture, but I like this one because it is so unexpected.

"The picture was taken on assignment in the south of France. I was near the end of the roll of film in my camera and I went into the farmyard to finish it. This picture was the last frame on the roll.

"Later everybody wrote something about 'The Tree and the Hen.' Nobody seems to know whether the background is a wall or the sky. We recognize an artist by the background in his picture, made apparent through depth of focus and atmosphere, and we recognize each other in friendship and love by this same background — the background of light."

FRANK HORVAT

"This is a personal photograph. It shows my first two sons, in a (barely) furnished flat in Paris where we lived at the time. It is one of my photographs that I like."

MY SONS MICHEL AND LORENZO 1958

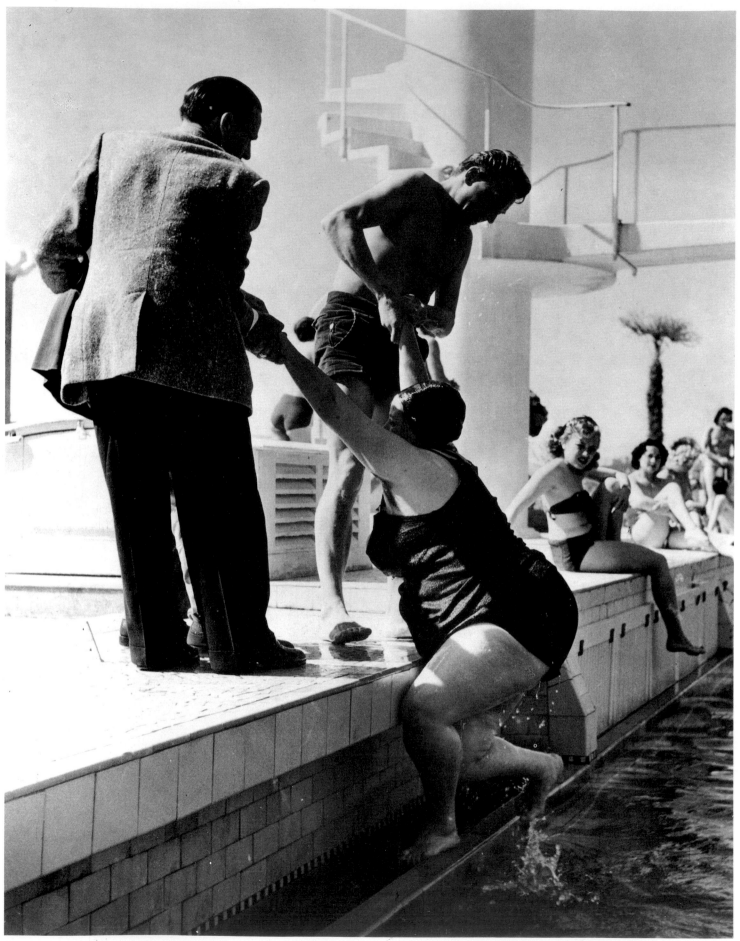

HELPING HANDS 1959

"In the studio the camera is subservient to one's intentions. We control final results to suit our style. Out of the studio we are affected by events out of our control. No posing, rearranging, or fakery: just luck at being there with the seeing eye. That's why this personal photograph taken in the south of France is one of my favourites. I was simply lucky in having a camera with me."

CORNEL LUCAS

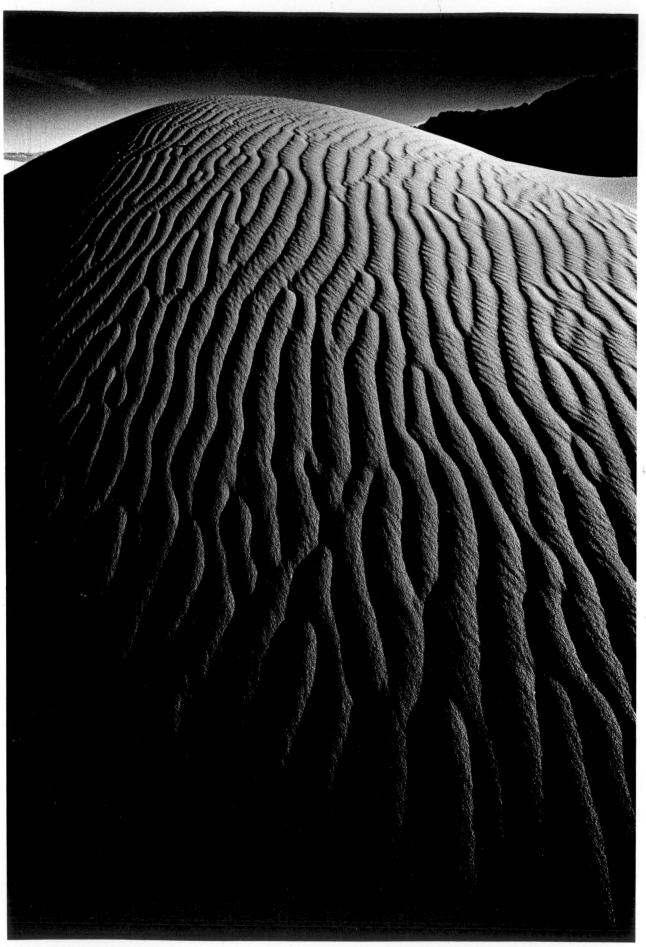

DEATH VALLEY 1977

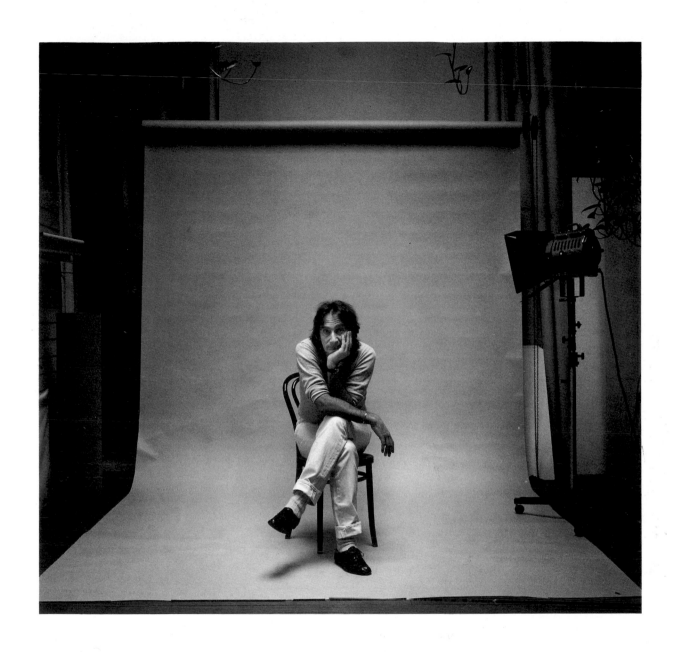

"Why is this my favourite? Because it was on top of the box that I happened to open when I went to choose one. Everything has a meaning in life! I took the photograph because I was there, on a late afternoon in Death Valley. I was in a very good mood, and so was the sand dune. The photograph was commissioned by myself to myself, so maybe it is personal?"

JEANLOUP SIEFF

27

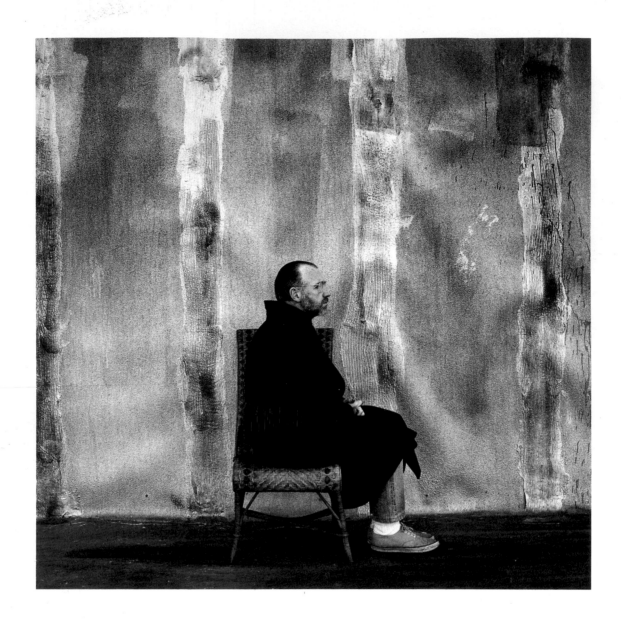

ALBERT WATSON

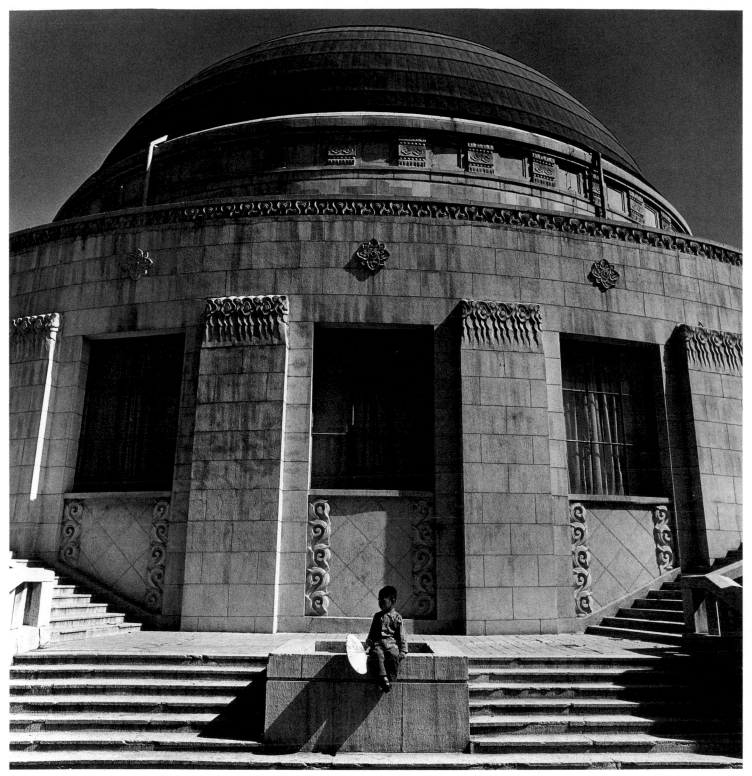

BEIJING OBSERVATORY 1979

"This photograph of the Beijing Observatory
is my favourite because it's simple. It is a
personal photograph, and I took it merely
because I saw it. The little boy in the picture
was waiting for his parents, who were inside
the observatory, and the obvious scale
change from the small boy to the large
building was interesting."

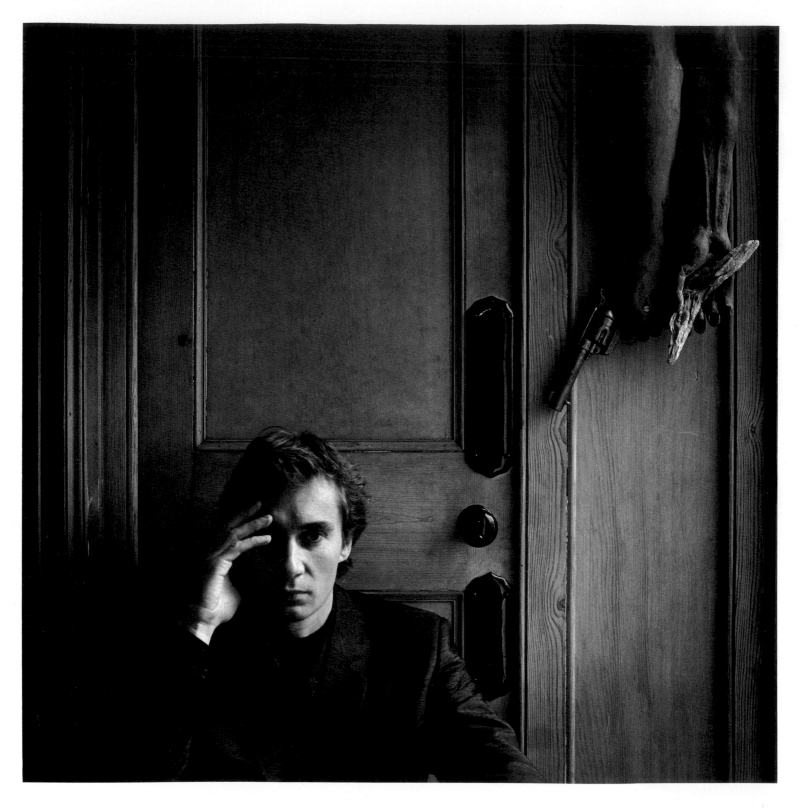

BOB CARLOS CLARKE

FOURTEEN 1985

"This photograph is reproduced from my book *The Dark Summer* (Quartet, 1985). I found this girl in a pasta bar, and photographed her a few days later in Brompton cemetery.

"She was just fourteen and had not been photographed before. She barely spoke, and I was worried that she might be nervous, but when we began to work she was so calm and posed so confidently that she needed no direction.

"I find it impossible to have a favourite photograph while there are still photographs to be taken, but I like this for its sensual feeling of melancholia — and the way she looked right through me."

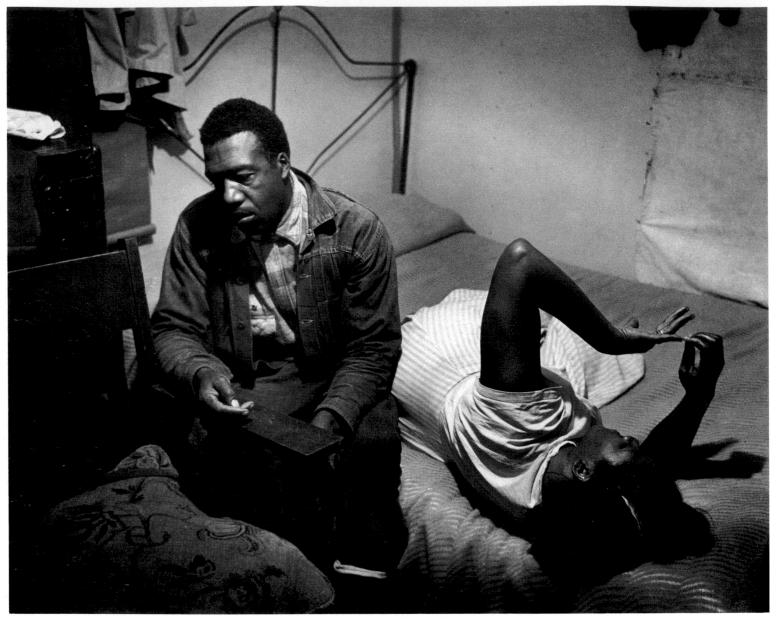

CALIFORNIA COTTON PICKERS 1950

"I made this picture on assignment for *Ebony* magazine. I don't have a favourite, but over the years I have made some images that dig below the emotional surface that most of us present to the world around us. This is one of them. I believe this man to be trapped not only by the world around him but by his inability to relate to the closest person in his life, the mother of his children."

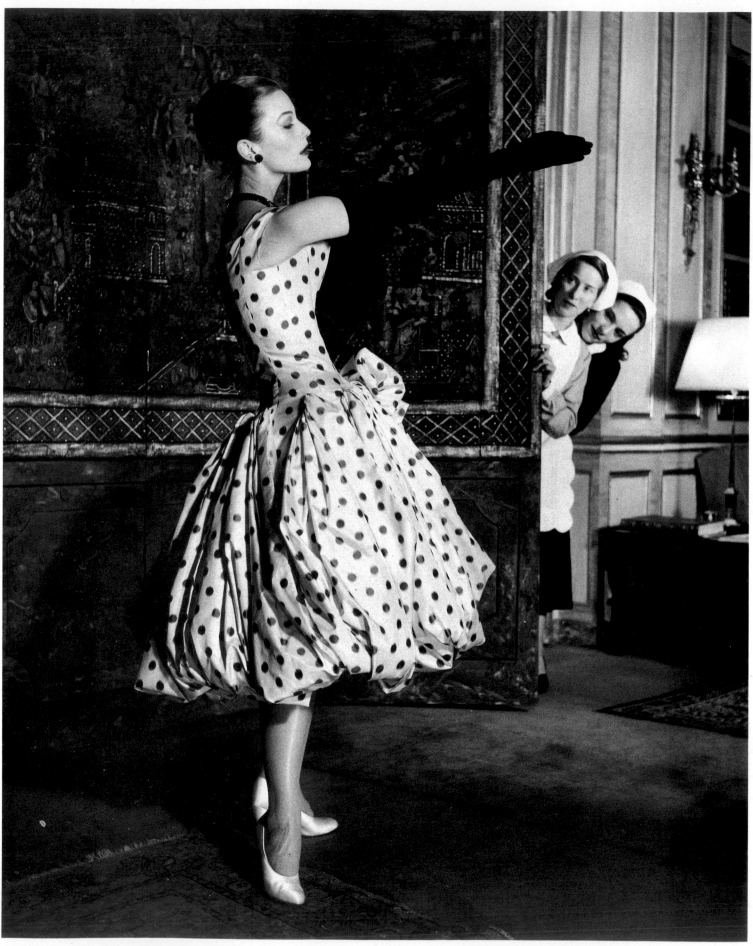

MARY JANE RUSSELL IN DIOR DRESS, PARIS 1950

LOUISE DAHL-WOLFE

HANS GEDDA

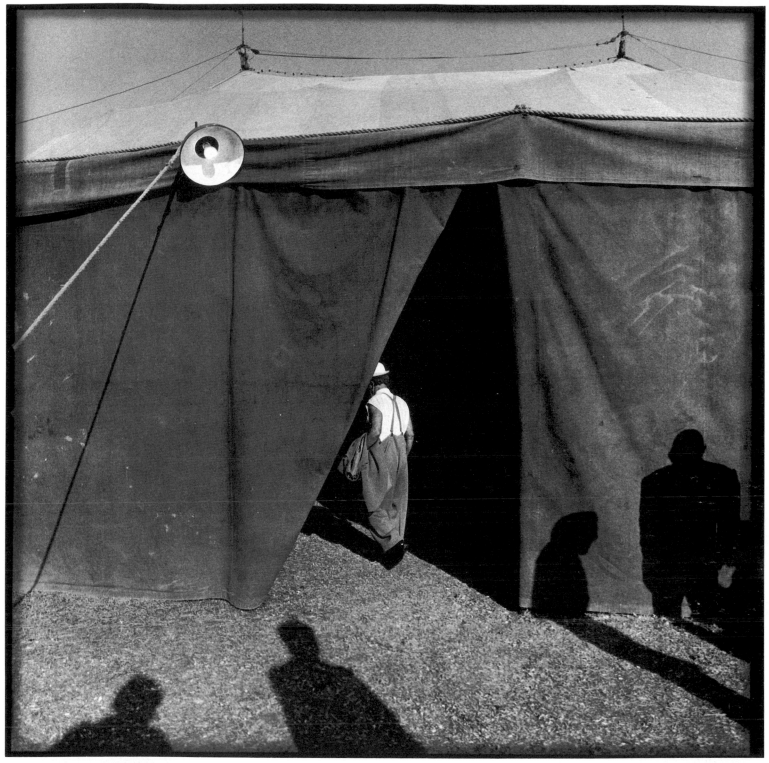

CLOWN WITH SHADOWS 1981

"This picture was taken in Stockholm as part of a personal project. I have chosen it as one of my favourite photographs because I believe I have captured momentarily an image of man's solitude — the loneliness which we all feel at one time or another. Or, as the writer Lars Forsell has written in my circus book:

"'We live, like the poor circus artist, not in the luxury hotel of the star, but in life's drafty and dilapidated caravan. We do not drink champagne at Riche, but must be satisfied with the dwarf's gruel. And not many people come to the show either.

"'Maybe one could dare to say that the comparison between life and our poor country circus is not quite fair on life?'"

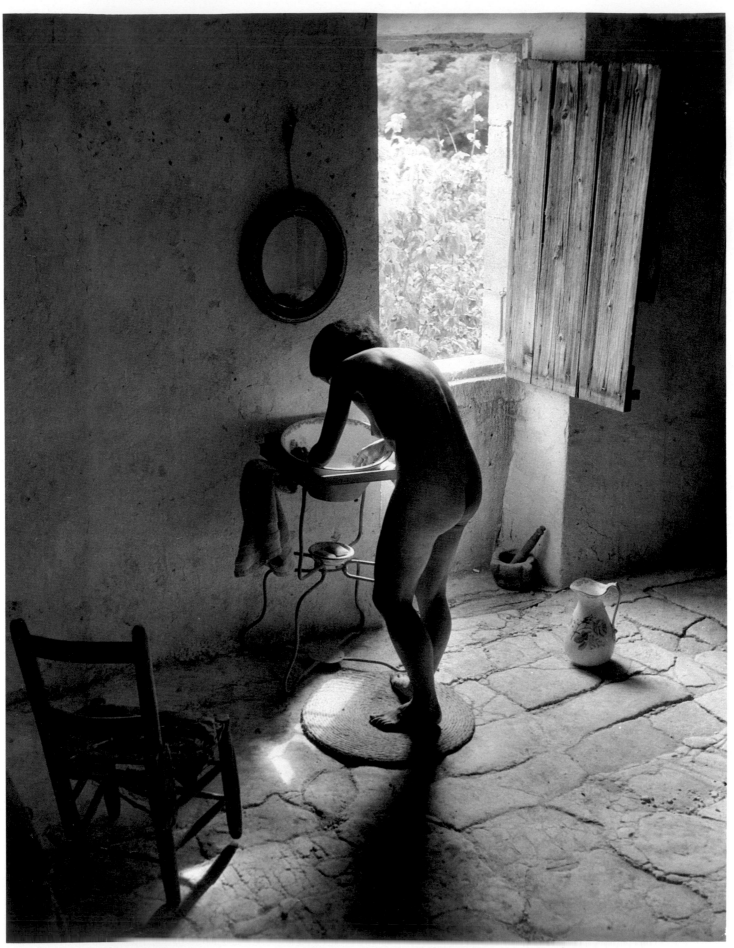

LE NU PROVENÇAL 1949

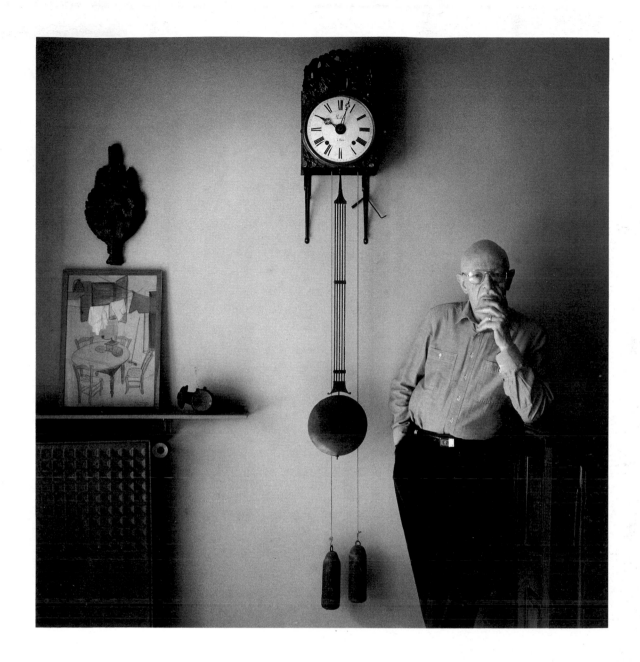

"I have no single favourite photograph but one favourite is 'Le Nu Provençal.' In August 1949, my wife and son and I were staying in Gordes (Vaucluse). It was especially torrid. I was working in the attic and needed something downstairs, so I took the stone staircase that went through our bedroom. Marie-Anne, just up from a nap, was washing her face with cool water in the washbasin.

"I told her to stay as she was and, taking the camera off the dresser, went up several steps and shot three times. Then I forgot about it, as there were many other photographs taken during that vacation. It was a big surprise, back in Paris, when I developed the contacts, but the destiny of this photograph still astounds me."

WILLY RONIS

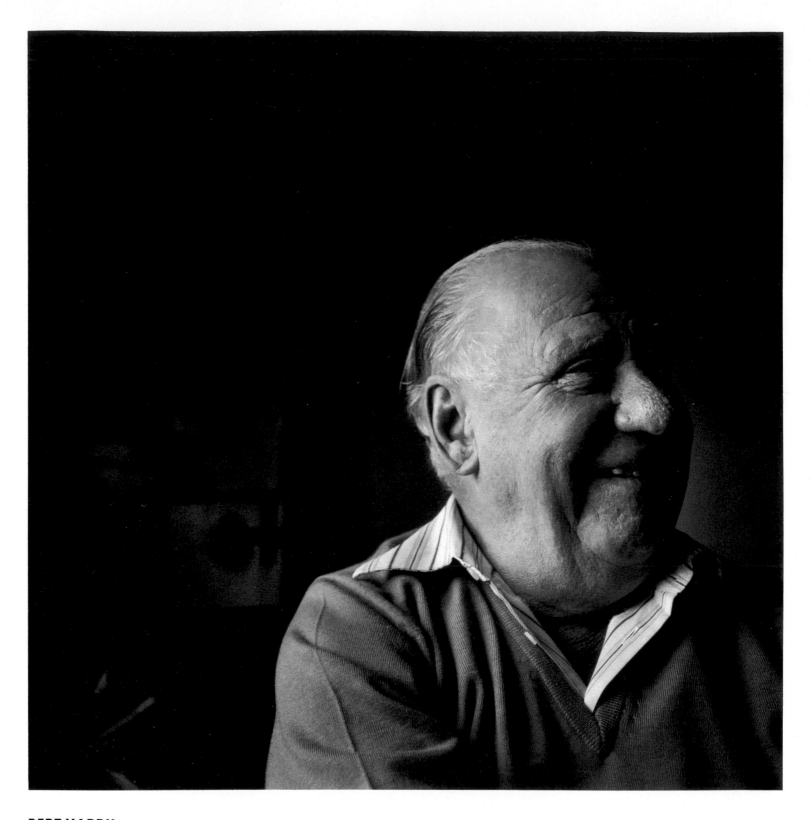

BERT HARDY

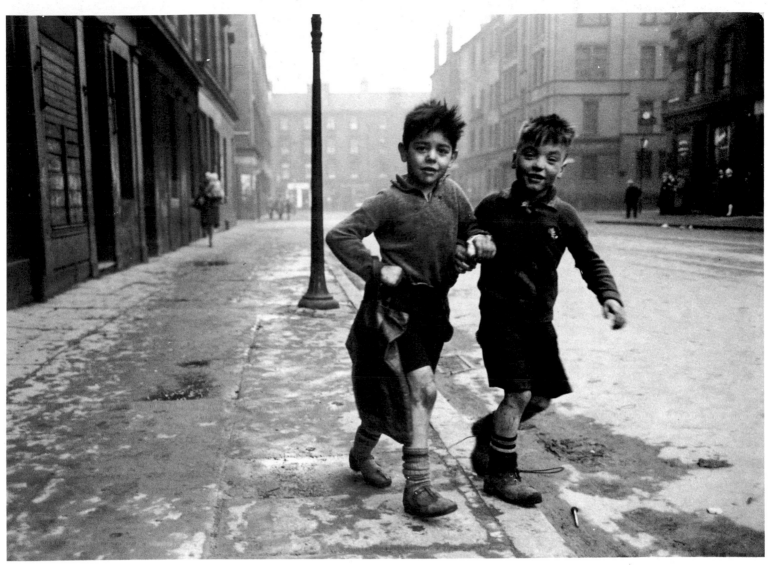

THE GORBALS 1948

"I took this picture in the Gorbals area of Glasgow for *Picture Post*. My Leica was set at 4 yards and a shutter speed of 1/100 sec. I came round the corner and snapped these two boys as they passed. I only took the one shot.

"I recently met the boys, who are now grown men. But this is my favourite picture because it reminds me of how I was as a boy."

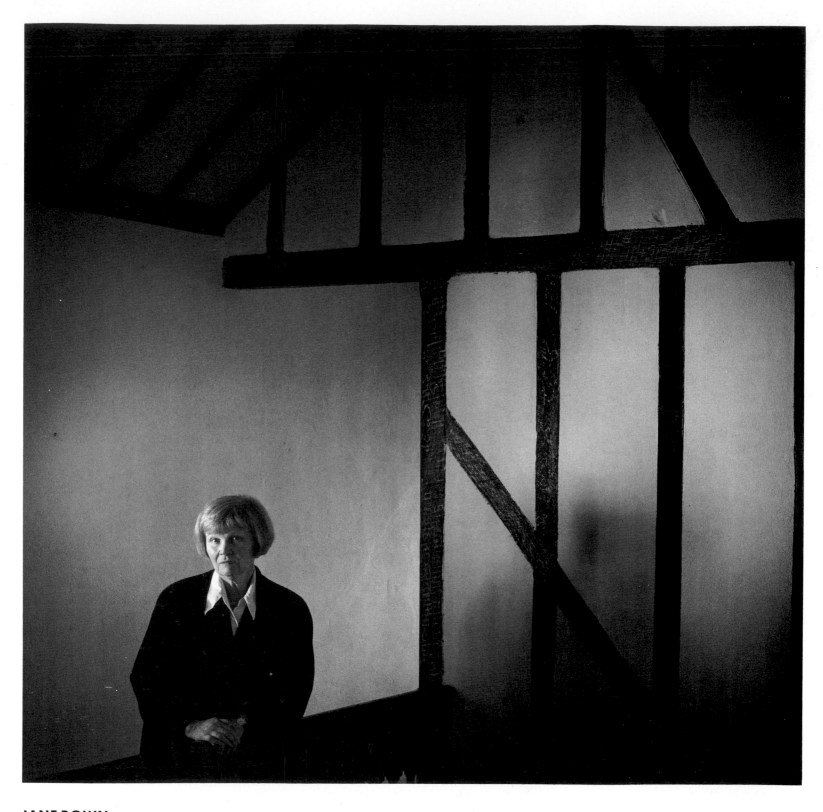

JANE BOWN

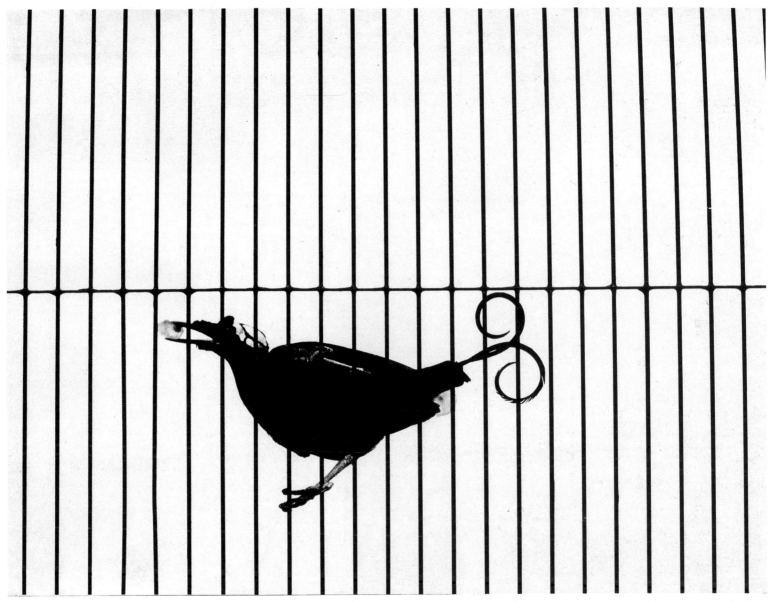

BIRD OF PARADISE 1974

"I was sent by the *Observer* to photograph the 1974 Caged Bird Show, a typical news job. It was a shot in the dark and a lucky one on a day when the exhibition was open and very crowded and where available light was almost non-existent. Photographic luck! The picture is my favourite because it is incredibly graphic and a welcome change from portraiture."

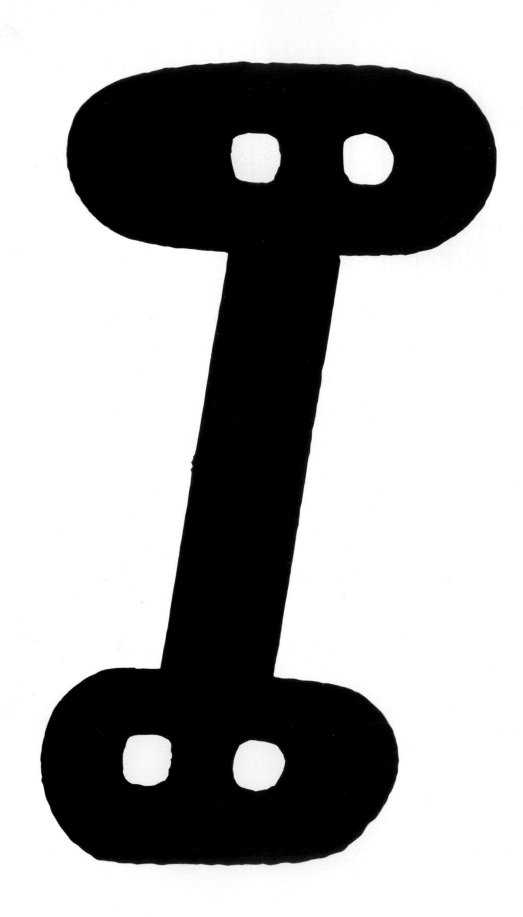

"It is a personal photograph. It was made by placing the object on a light table and taking an exposure on normal 8 x 10 sheet film through a repro lens and then contact-printing the negative on portrait paper."

DAWID

2673, 1986 (from the ROST series) 1987

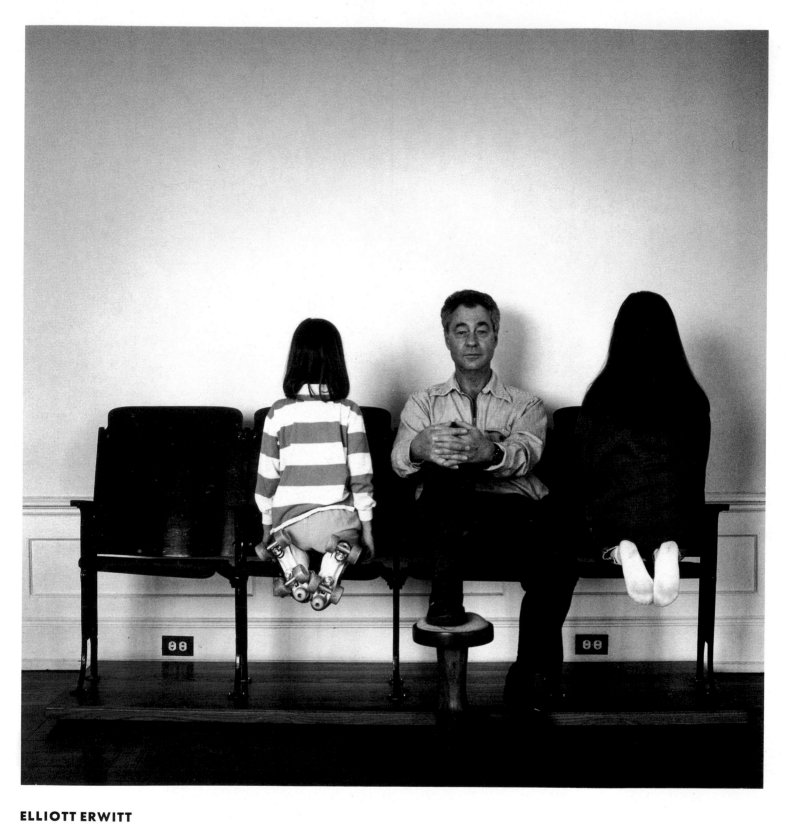

ELLIOTT ERWITT

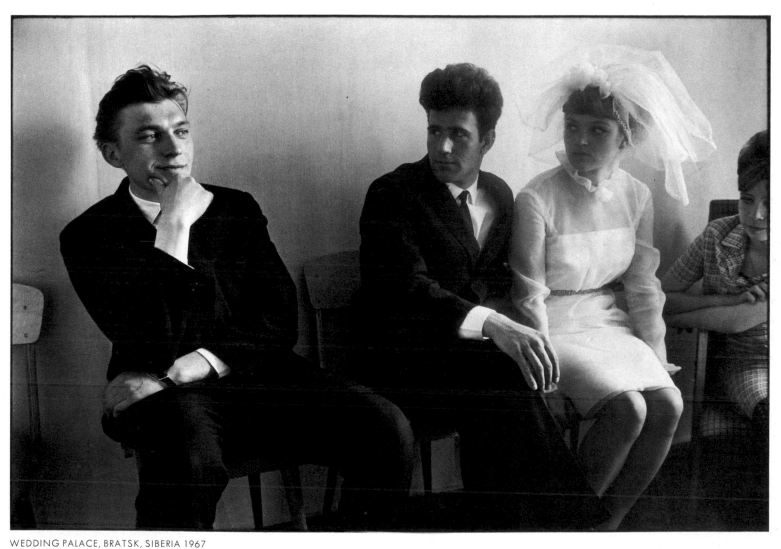

WEDDING PALACE, BRATSK, SIBERIA 1967

"I don't really know if I have taken my favourite picture yet . . . and it does take time to have a favourite. When I do take it, I'll send you a telex. This picture was taken in Bratsk, Siberia. It was definitely a vertical."

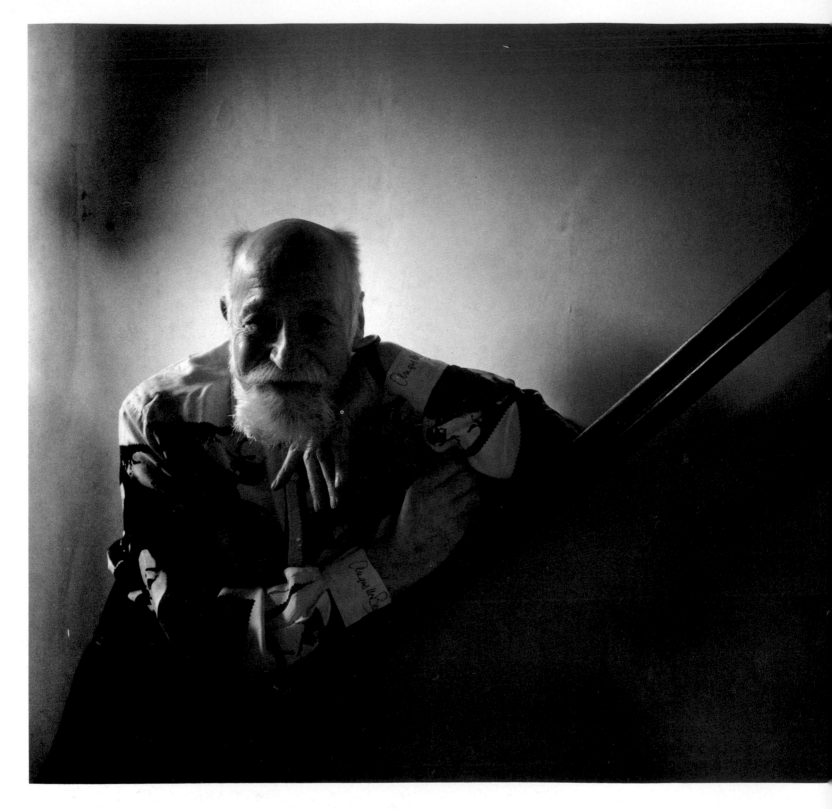

ANGUS McBEAN

"This picture was taken on commission at my Endell Street studio. It was chosen by the National Portrait Gallery in London, and will also be on the cover of a book by me called *Vivien: A Love Affair in Camera*, which is coming out shortly. So it must be my favourite picture — in any case, she is easily my favourite sitter!"

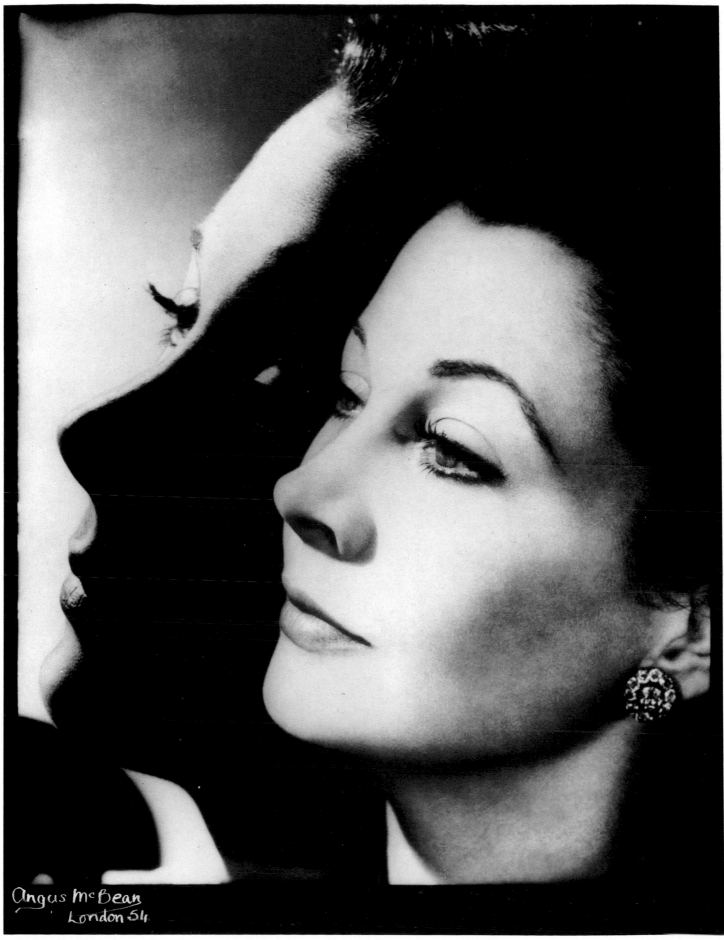

Angus McBean
London 54.

VIVIEN LEIGH 1954

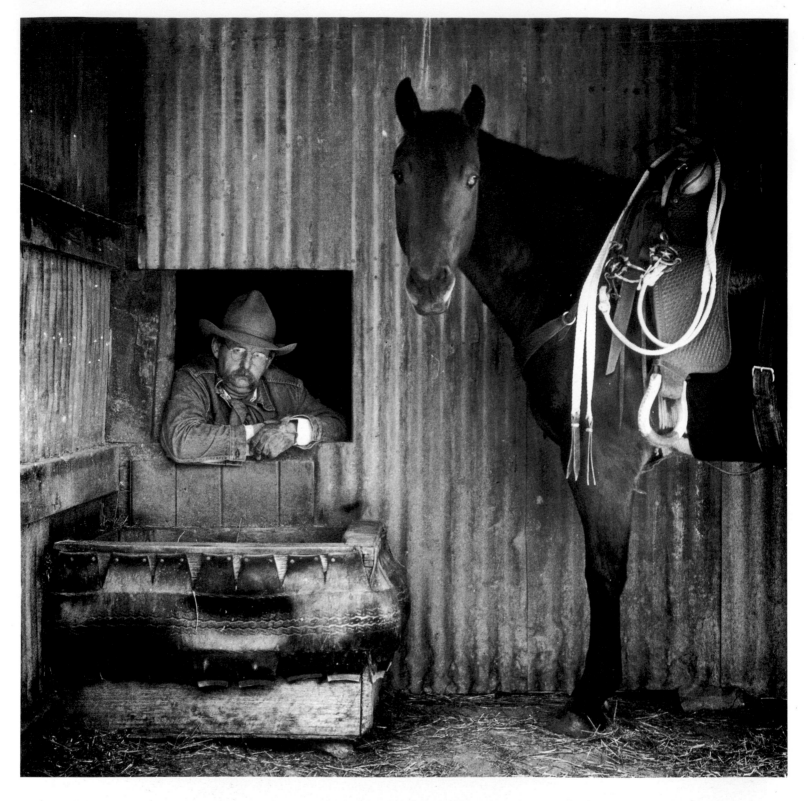

JAY DUSARD

"This is from a series of view camera portraits of working cowboys. A sculptor friend told me about Bob Pulley, who he said was one of the finest cowboys in our neighbourhood. After an initial session Bob invited me to the A Bar V for the spring roundup. I rode with Buster and Bob for five days, helping gather cattle and brand calves.

"I made this portrait after work one day in a barn that was open on the east side. With the camera set up and the composition established, I pointed out to Bob and Buster that there was a place for one man to sit and one man to stand. They picked their spots and assumed their poses. I simply focussed, made my light readings, figured the exposure (1 second at around f16), and fired a couple of shots.

"I am very taken by the strong composition of this photograph and the three-dimensionality of the human forms. Both men are very good cowboys, and Bob Pulley has become a close friend. In the center of the image, where someone must have cleaned a paint brush on the wall, is a wonderful Aaron Siskind-like abstraction."

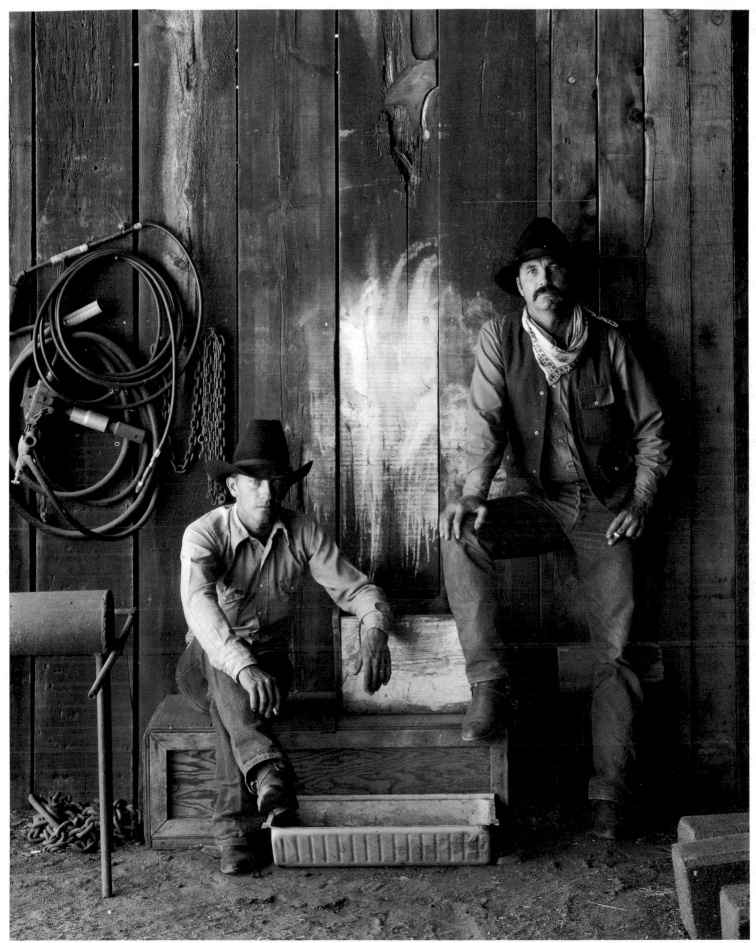

BUSTER SCARBOROUGH AND BOB PULLEY, A BAR V RANCH, ARIZONA 1981

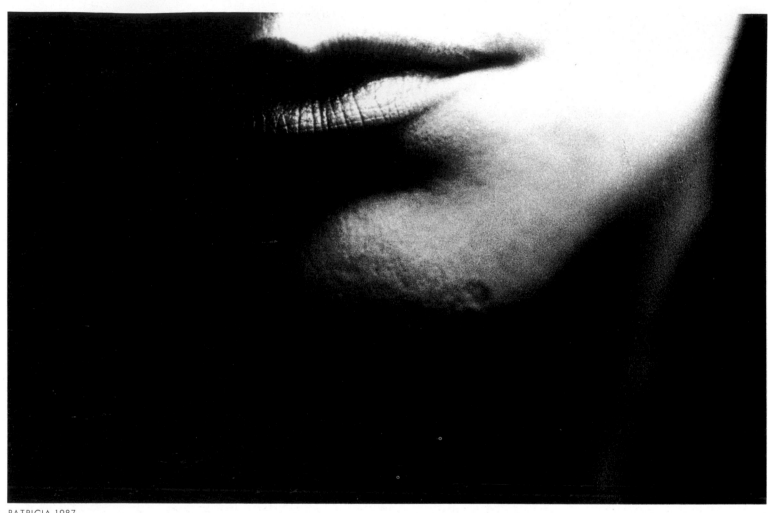

PATRICIA 1987

"I took this photograph in Rome. Like any
personal work it is self-defining. I want to
make photographs that look at me: not
vice versa."

RALPH GIBSON

BRETT WESTON

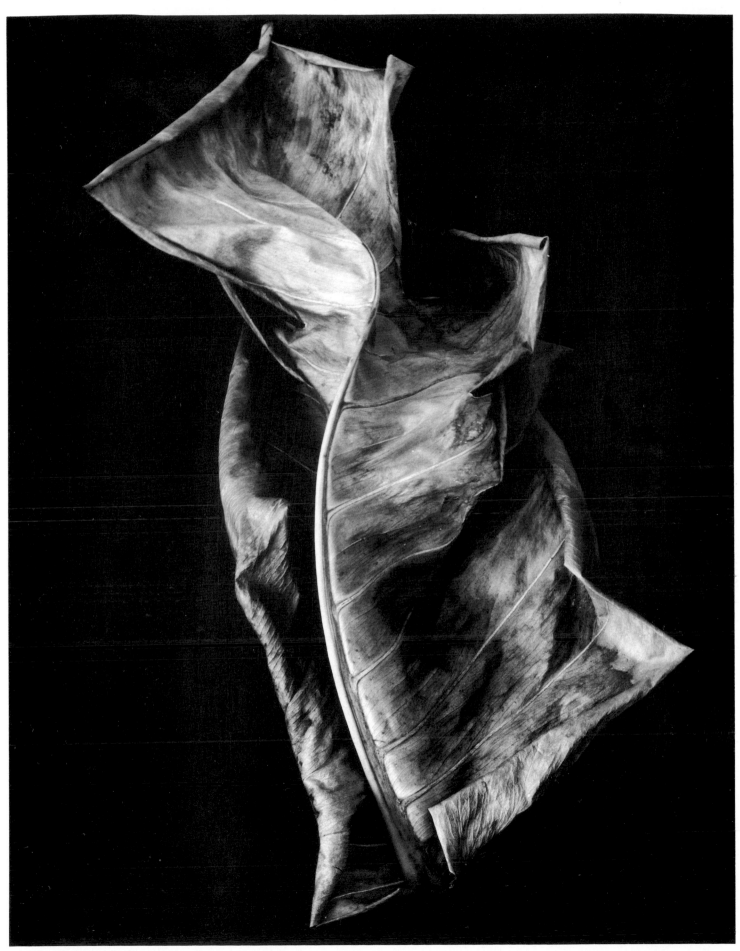

SEA LEAF, HAWAII 1987

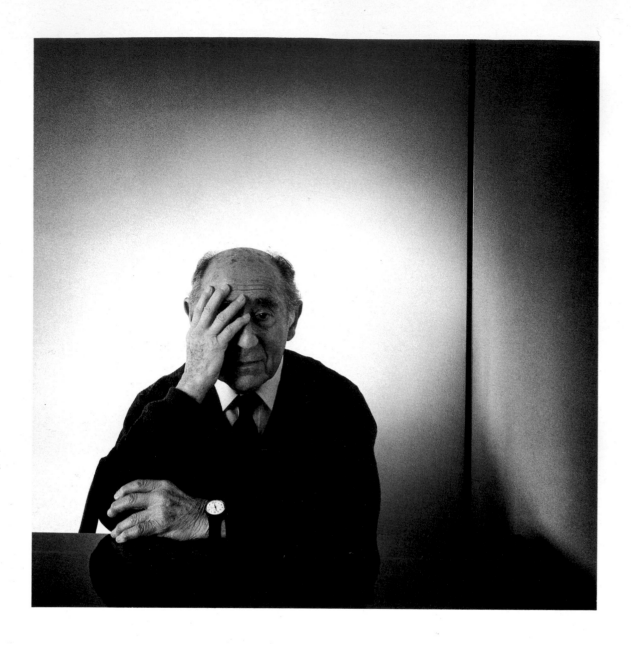

ALFRED EISENSTAEDT

"I was on an assignment in Milan for the German fashion magazine *Die Dame*. After shooting boxes with elegantly clad people I looked around for a more interesting picture. I fixed my eyes on a box with this beautiful girl sitting in it and asked permission to occupy the empty box adjoining hers.

"I like the picture because I took it early in my career. I also like its composition,

elegance, and the circumstances in which it was taken. The picture won many prizes all over Europe. It was taken with an early model Leica on a rickety wooden tripod. I had no exposure meter and had to guess the exposure, which was about half a second. The peformance was of Rimsky-Korsakov's *The Legend of the Invisible City of Kitesch.*"

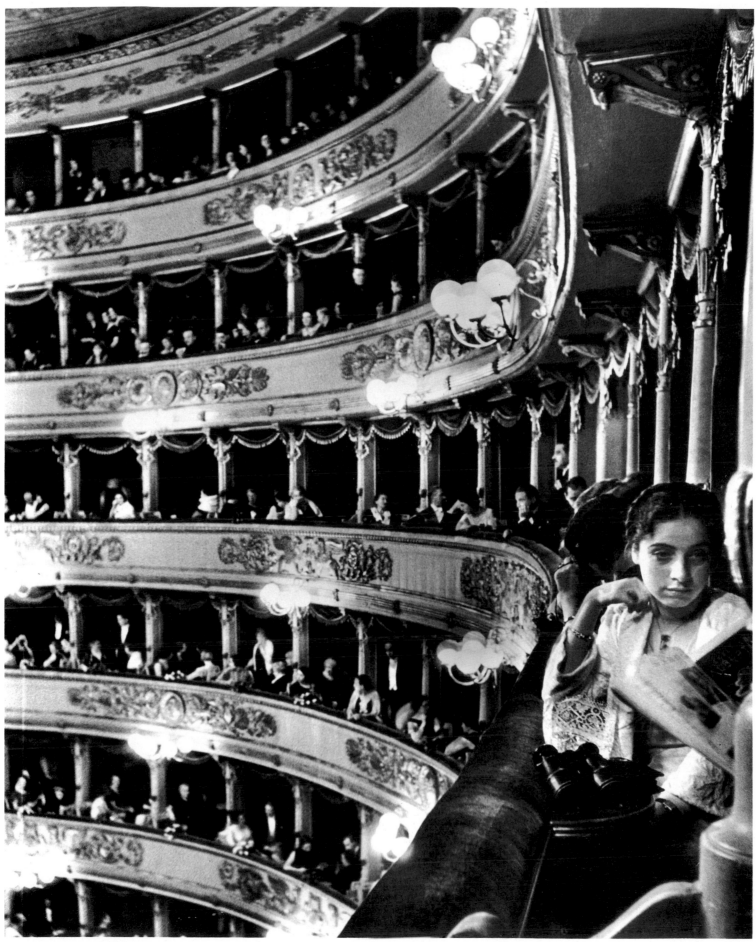

GALA PREMIERE AT LA SCALA 1934

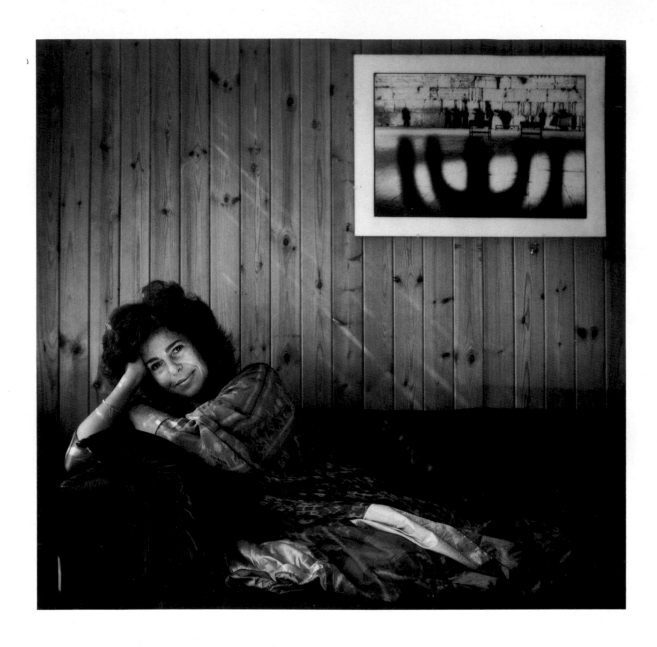

SALLY SOAMES

"Favourite photographs for me are about memories. This recalls the memory of meeting Nureyev, who had given me so much pleasure on the many occasions I had seen him dance. It was commissioned by the *Sunday Times* for Nureyev's fortieth birthday and taken in the wings of the London Coliseum, during a performance of *The Sleeping Princess*. Nureyev's role did not require him to dance in Act 1, and I took this after he had been limbering up and was about to return to his dressing room to change into costume for Act II."

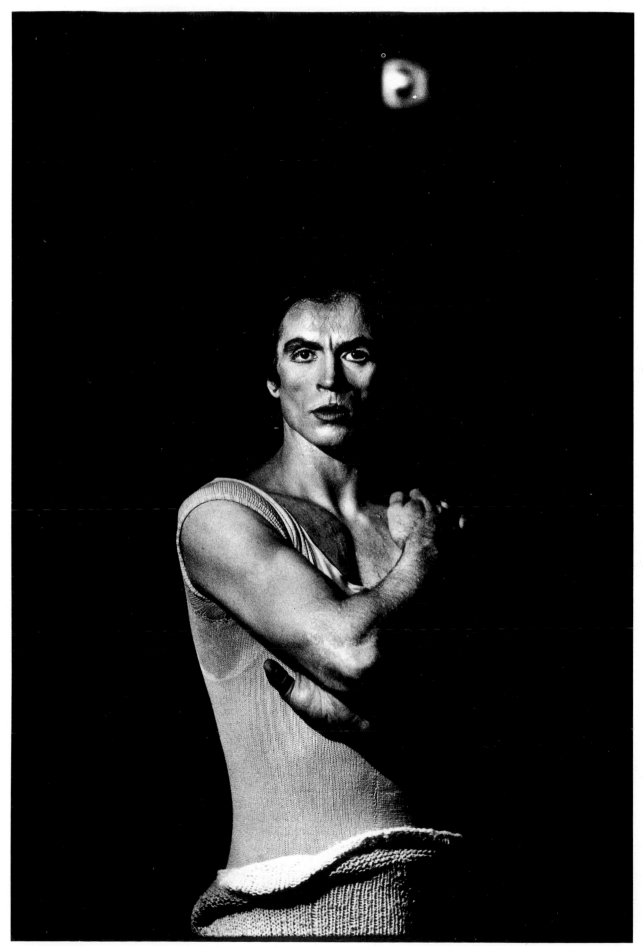

NUREYEV 1978

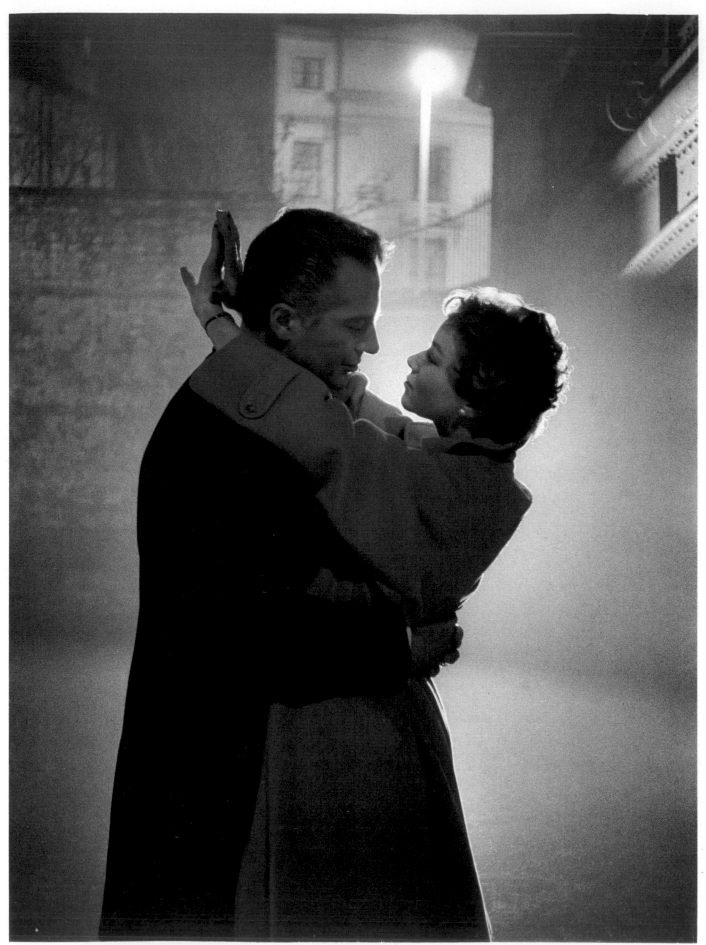

ROSSANO BRAZZI AND JENNIFER PUCKLE IN PADDINGTON, LITTLE VENICE, LONDON 1955

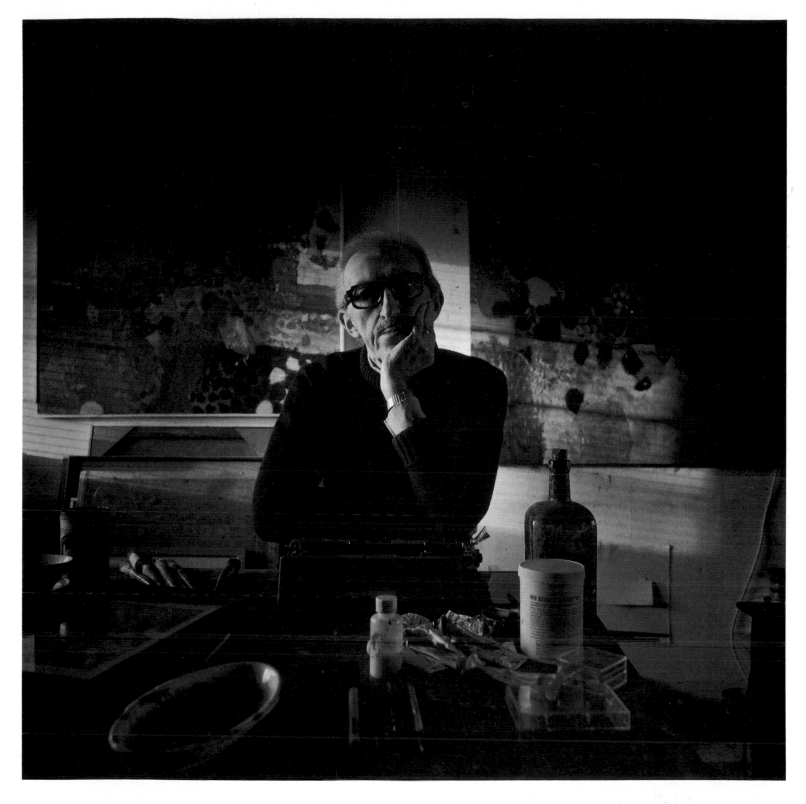

THURSTON HOPKINS

"Occasionally, after sweating on a succession of exhausting 'hard' assignments, you received a lightweight 'lollipop' story, often from the world of entertainment. I always enjoyed working on them. You would be given an actor for a few hours, and you and the writer had to dream up a situation that would produce an amusing sequence of pictures. Because Rossano Brazzi was filming all day, I had to photograph him and Jennifer Puckle at night.

"As it turned out, this was to my advantage. There was a touch of fog in the air and it was too dark to see what I was going to get from this hurried setup, so I had my writer, Robert Muller, crouch behind them with an unsynchronized flashgun. I set my Leica to B bulb and pressed the shutter release, and when I yelled 'Fire' he set off the flash and the peanut bulb exploded.

"I probably took a hundred pictures that night and into the early hours of the morning, but I thought this one worked best. It was not published because it was the wrong shape: an upright that didn't fit in the layout!"

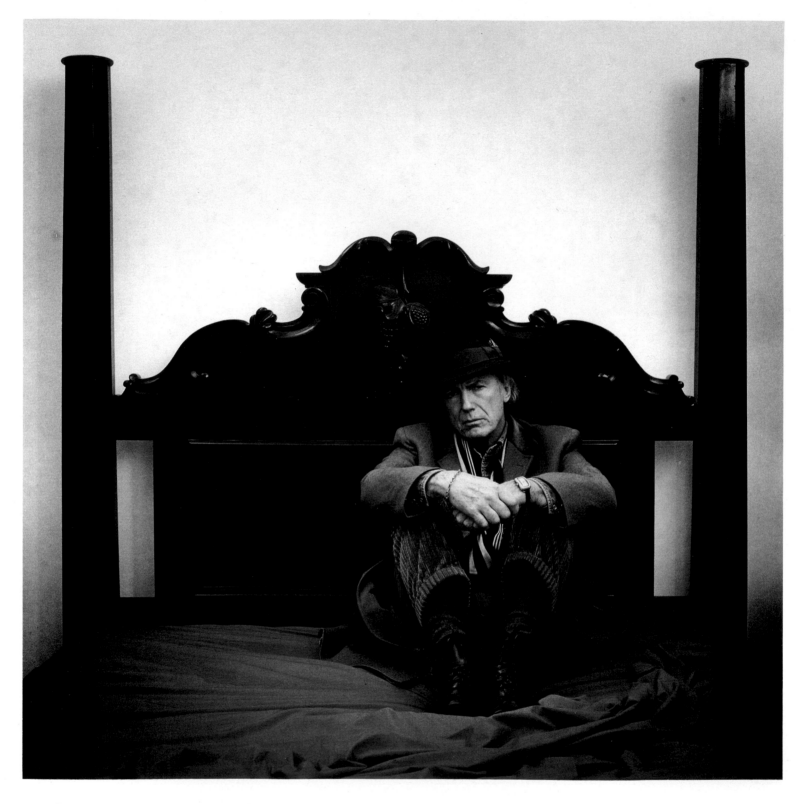

CHAD HALL

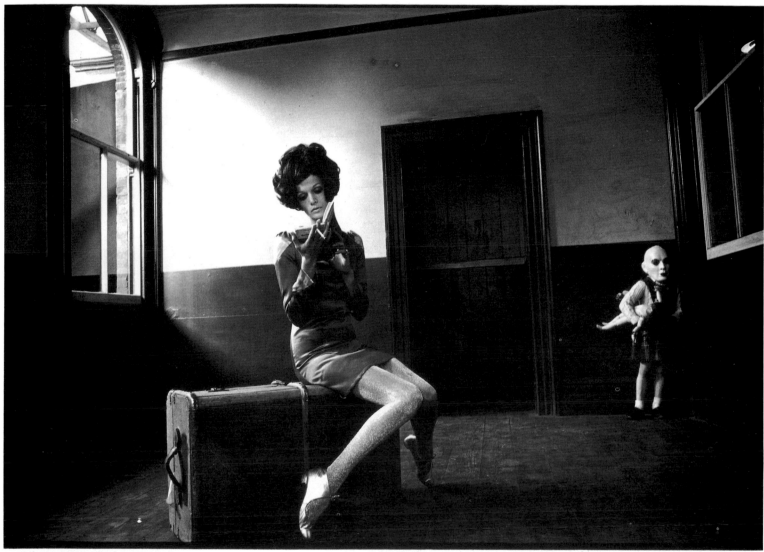

WAITING ROOM *c.*1965

"One type of 'good' photograph is one that has an incongruity or rupture in it — something that cannot be viewed literally, which uncovers a state of mind, an attitude or situation and which can be read on more than one level. 'Waiting Room' is as near as I've got to this goal. The design of a picture can go against the nature of the subject as a means of adding drama or meaning to it. In 'Waiting Room' the graphic element is designy and very still, a fact that I feel plays off the grotesqueness of the little figure in the corner.

"'Waiting Room' was part of a series for French *Vogue* and was taken in a now-demolished South London railroad station. This shot was rejected."

WILLIAM KLEIN

ROCK CONCERT, PARIS 1982

"I had practically stopped taking
photographs (to make movies) for about
fifteen years. Then, in the beginning of the
1980s, a sort of comeback. For exhibitions,
books, assignments — but mostly for myself.
How to pick up where you left off, the
reflexes, the approach, the rhythm.

 "This is a souvenir of a day when I felt I
was back in shape."

CORNELL CAPA

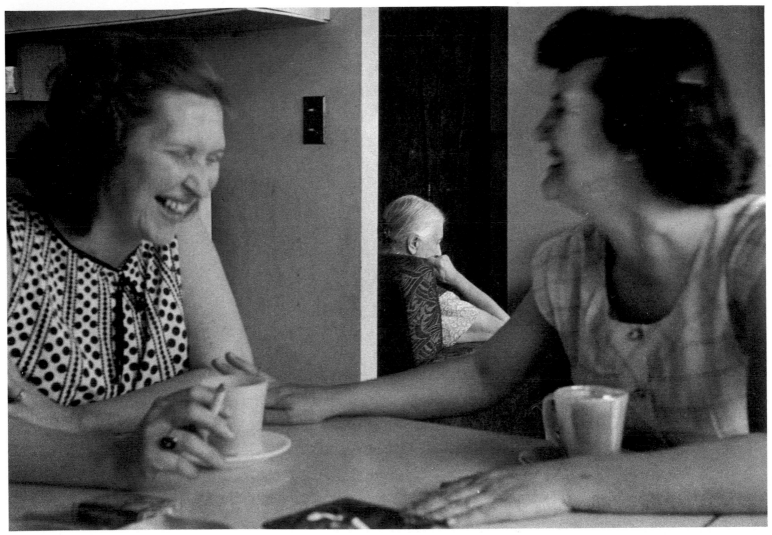

GENERATION GAP 1958

"I took 'Generation Gap' for a 1958 *Life* essay on the problems of ageing. After an extensive search we located the Mahaffey family of Philadelphia, Pennsylvania, who accepted me as 'a member of the family' for a whole week.

"The story was a ten-page spread of pictures and text. This photograph was used over a double-page spread. Critically focused on the mother, it is especially gripping because it shows graphically the emotional loneliness of ageing.

"Everyone has a mother. Mine was also a strong, old-country one, like Annie Mahaffey. I felt and shared her thoughts: 'Because I am eighty years old, nobody wants to listen to me. I have nobody to talk to.'"

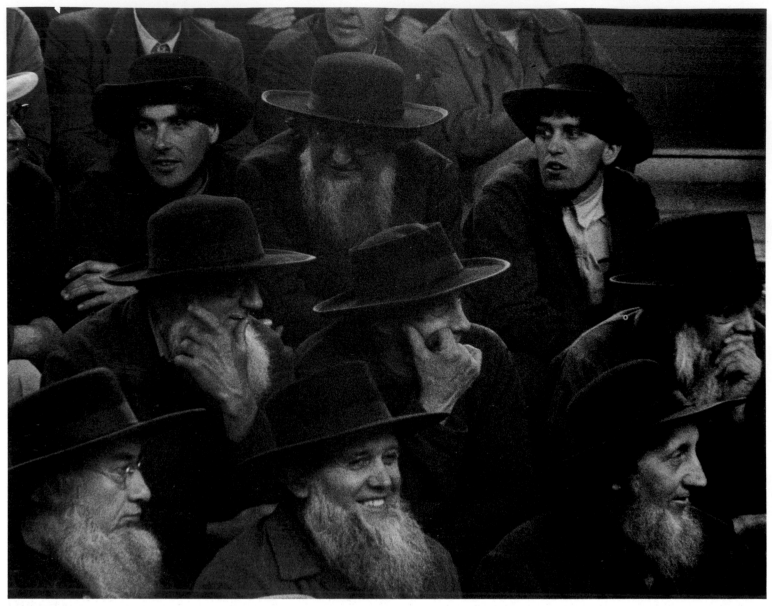

AMISH FARMERS AT HORSE AUCTION, NEW HOLLAND, PENNSYLVANIA 1955

"I wanted to make a photograph showing
Amishmen. Due to their religious beliefs this
was not possible, but I was told about a horse
auction in New Holland. Many Amishmen
would be there, and they would be so busy
looking at the horses that I wouldn't be
noticed. The auction was in a dark barn, but
with a tripod and some luck I was able to get
this photograph."

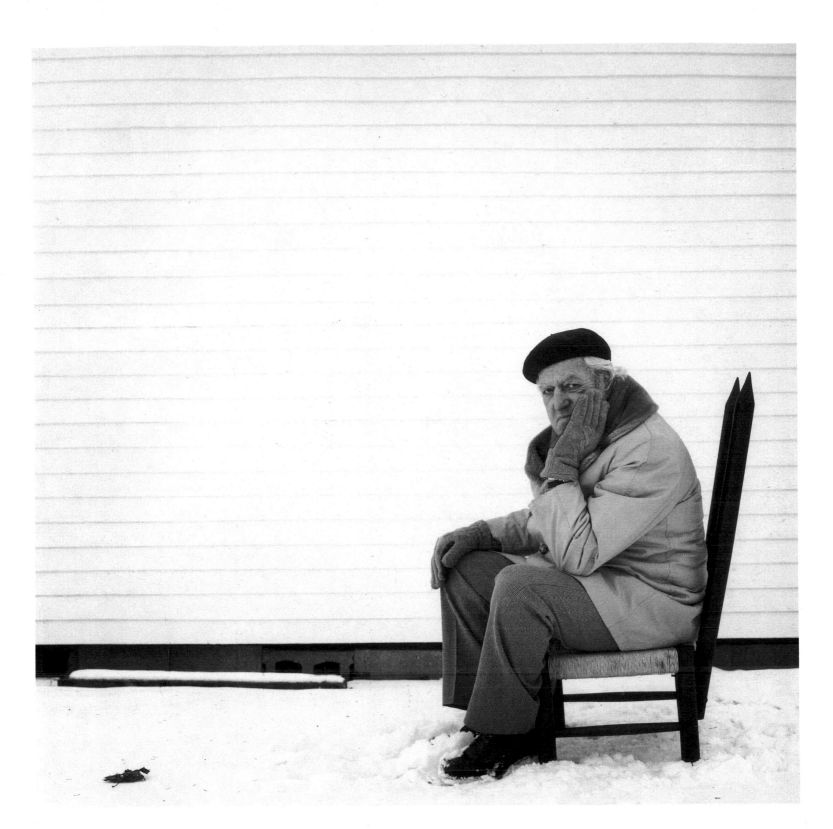

TODD WEBB

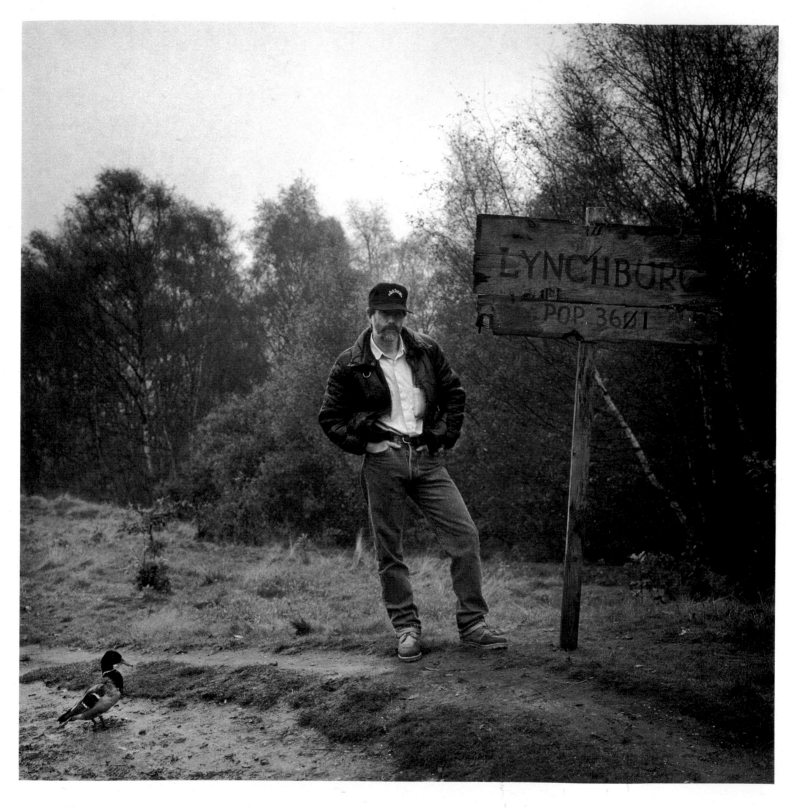

JOHN CLARIDGE

"My introduction to jazz (at the age of twelve) was Chet Baker playing with Russ Freeman and Shelly Mann. Thirty years later I took his photograph in London. Baker suffered a lot through the years but still played like an angel. I hope this picture shows some of his soul. It is a personal picture, a very personal picture. Shouldn't most pictures be that way?"

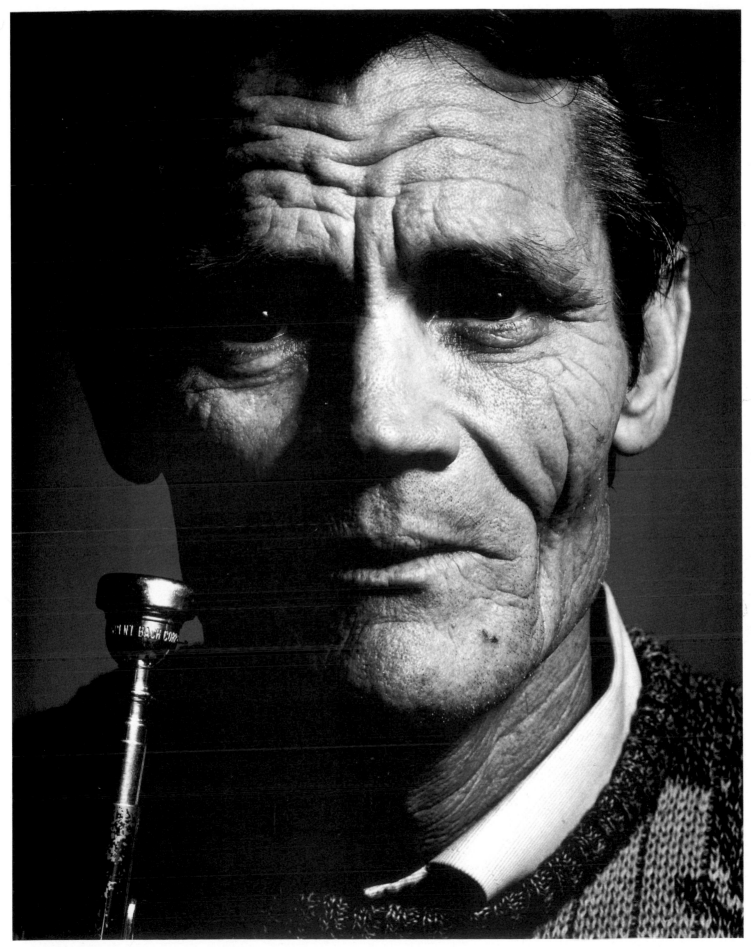

CHET BAKER 1986

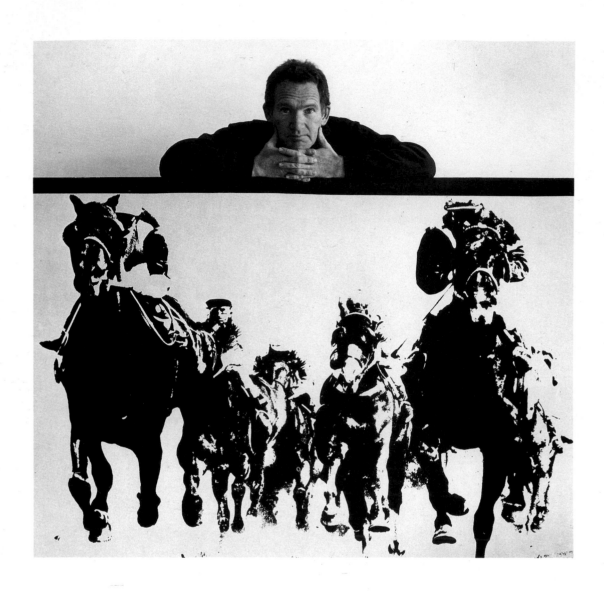

CHRIS SMITH

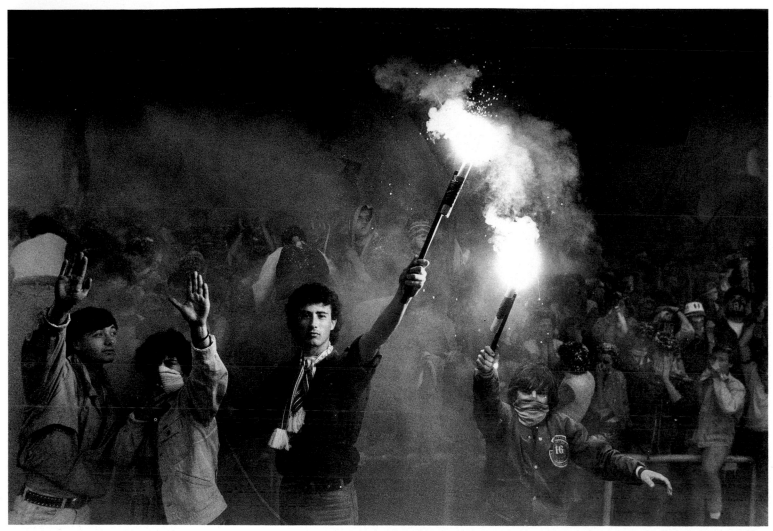

ROMA SOCCER FANS 1984

"I found this scene on the terraces at a
soccer game in Rome, and to photograph it I
had to climb onto the terrace with the fans.
The foreground figures with thrusting arms
and calm expressions balance very well the
chaos behind.

 "I have several 'favourite' pictures, and
change my mind every so often as to which I
like best. At the moment, this is the one."

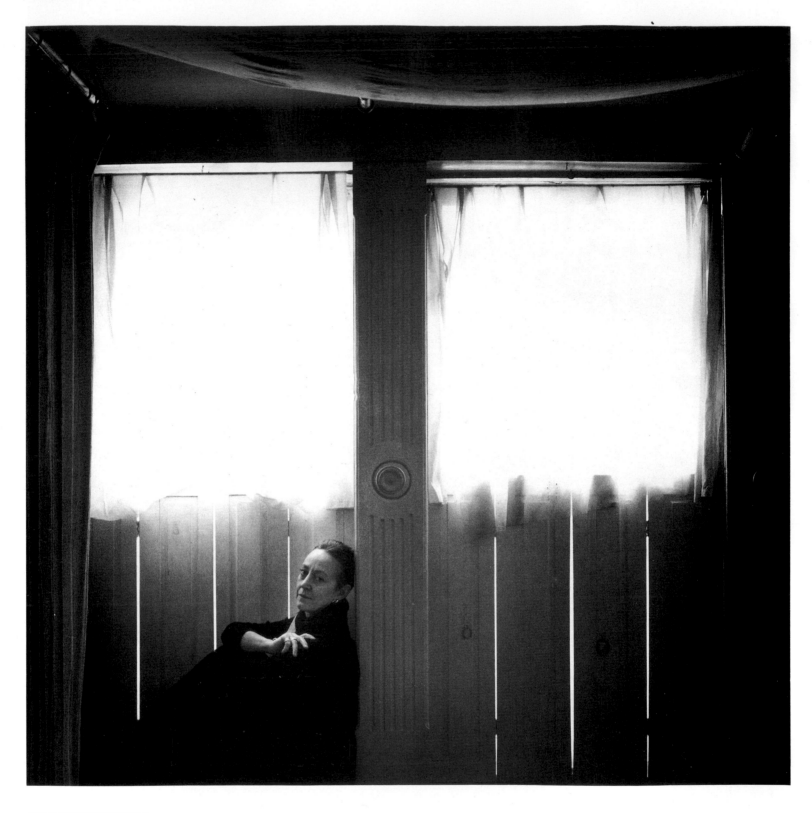

EVA RUBINSTEIN

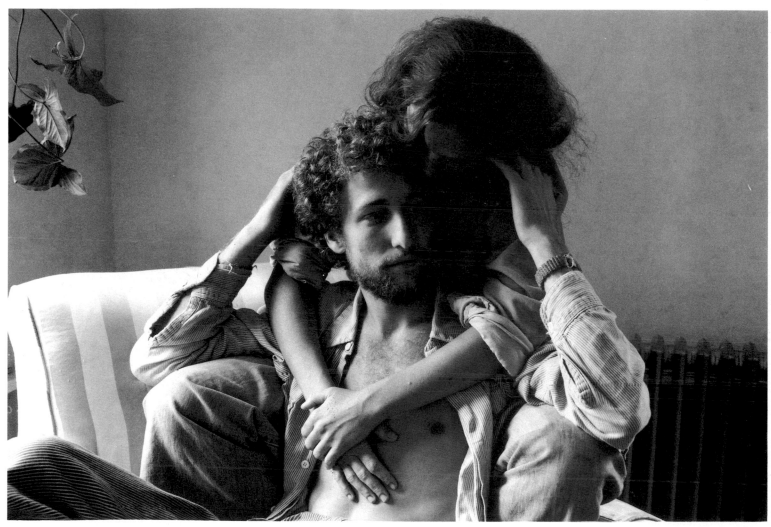

DAVID, WITH J. 1981

"It is difficult to call *one* image my favourite. When my father was asked what his favourite piece of music was, he always replied: 'The one I am playing at the moment.'

"This is a photograph of my son David and the young woman he was living with in Stockbridge, Massachusetts. I spent a few days with them and we had a wonderful time together. Most of the pictures I took there were simply 'family pictures.' But there are perhaps three that I would call 'photographs' — images I can show with no explanation. The line between the two categories is a very fine one.

"This image, one of the 'photographs', has a very special resonance for me. First, it reminds me of one of the best times I have spent with my son. And I like it 'photographically' because it is not quite as straight as it appears; there seems a slight dichotomy between the attitudes of the two subjects. Perhaps what distinguishes 'photographs' from 'family pictures' is an element that can be called universality. Paradoxically, that element seems to occur precisely in one's most deeply personal photographs."

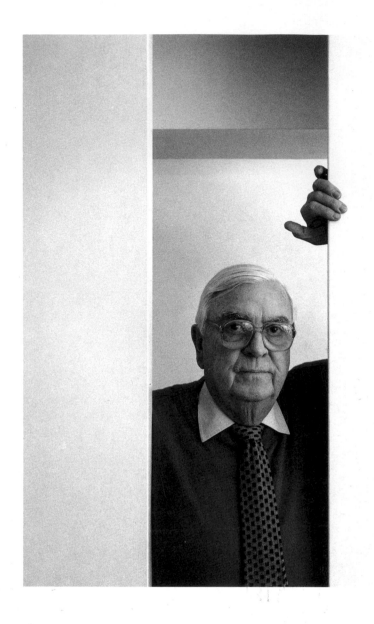

JOHN PHILLIPS

"I took this photograph in Eboli, southern Italy, the locale for Carlo Levi's famous novel *Christ Stopped at Eboli*. This picture was taken for my personal pleasure. I like it because it exemplifies most of the things I enjoy."

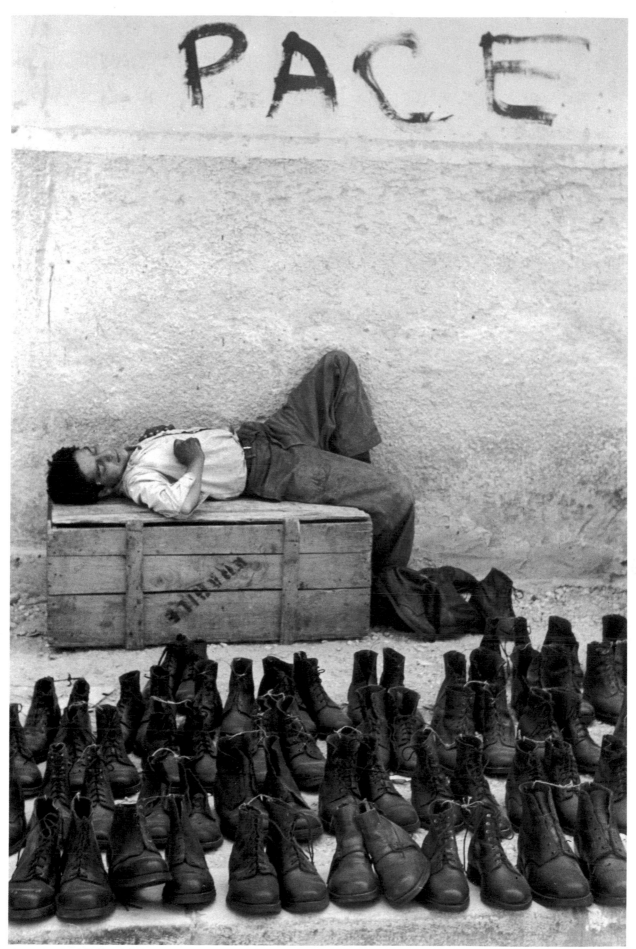

PACE (PEACE) 1951

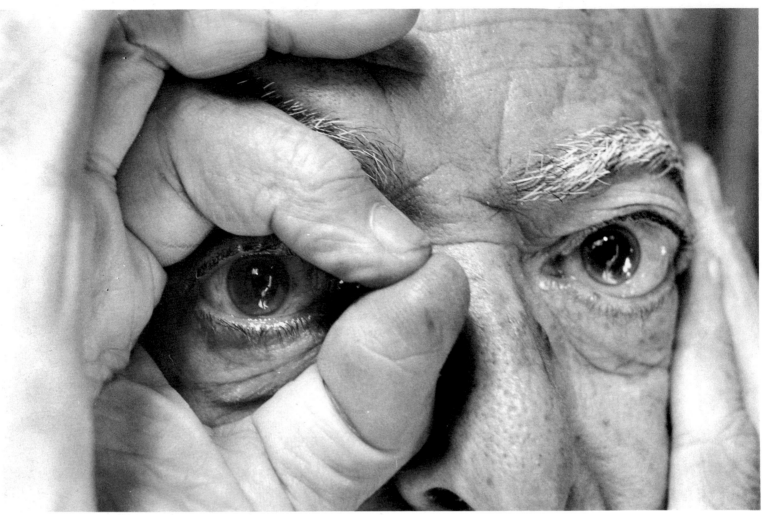

FACE OF BRASSAÏ 1981

"This photograph was taken at Brassaï's Paris studio as part of a *Life* essay on photographers born in the nineteenth century. The others included Eisenstaedt, Lartigue, Abbott, Van der Zee, and Kertesz.

"I took the picture with my lens only a few inches from Brassaï's face. My fingers were turning the barrel to focus, and seeing that motion he brought his hand up to mimic me. I made several exposures, then reached the end of a roll. I asked if he could do it again, as I wasn't sure I had it on film. He readily obliged, but there was something missing. When I looked at the contact sheets I saw that I got the picture on that first exposure.

"Asking which is my favourite photograph is like asking which of my children is my favourite. But what I love about this one is that I have been fascinated with the landscape of the face. When you come in close, the face takes on its own reference points. There are hills and valleys, rifts and ponds. To me it is much more exciting than the Rocky Mountains.

"Brassaï later asked if he could send this photograph to people when they asked for his portrait."

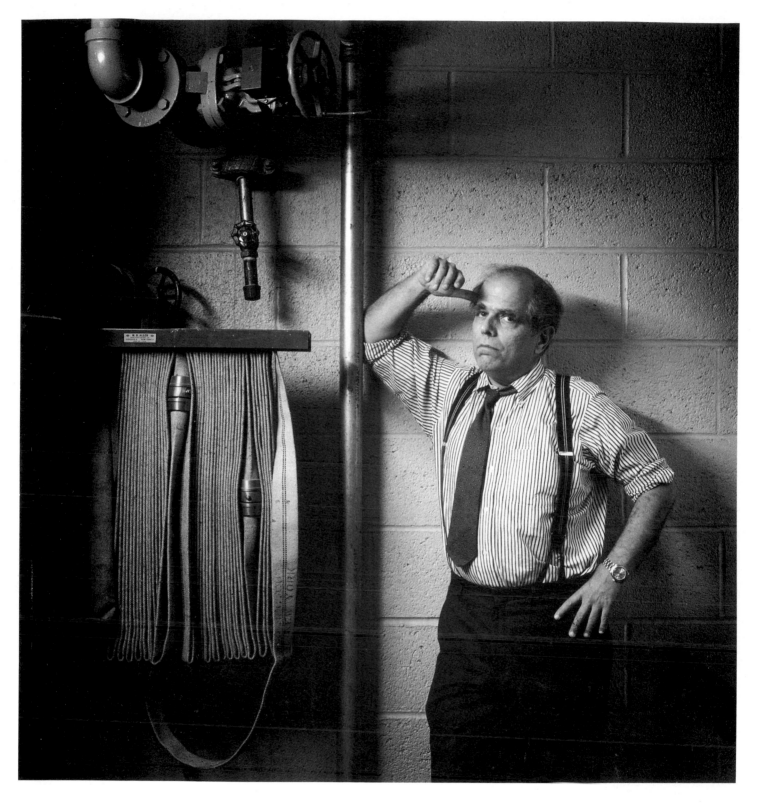

JOHN LOENGARD

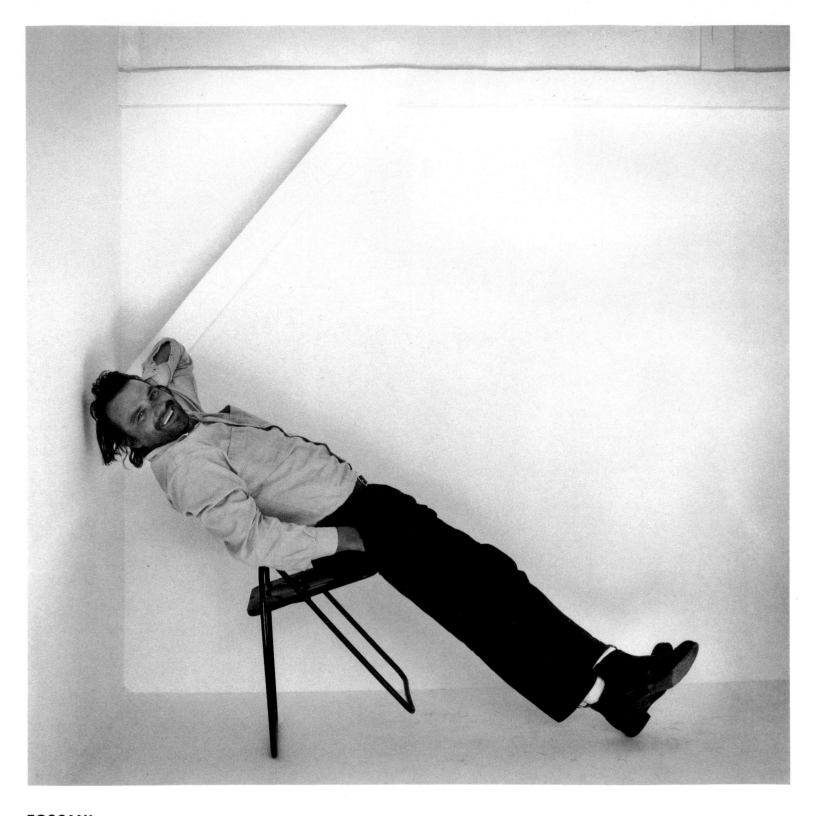

TOSCANI

UNITED COLORS OF . . .

"'United Colors of . . .' is my favourite
because it represents to me the hope of
tomorrow — and because I haven't taken my
next picture yet. The date when I made it
doesn't matter — if you want to know more,
just have a good look at the picture."

OTMAR THORMANN

"I really can't think of anything to say that would add something to this picture. It was made in the studio, and I took it because I had to, for my own satisfaction. It is a personal photograph.

"I don't really have a favourite from my own work, but I have chosen this one because it's one picture that I'm satisfied with at the moment."

SOLDIERS 1987

HORST

84

"This picture was taken as part of a colour perfume catalogue for Neiman-Marcus of Dallas, Texas, as a tribute to *Flowers and Fragrances* — their legend, lore, and language through centuries of romance. I made it in my New York studio with tungsten light and using a painted sky backdrop. It was photographed both in colour and in black and white.

"The photograph is currently one of my favourites for several reasons. Partly because the small porcelain figure was made by Eva Weidemann, a young Bauhaus dancer at Weimar in the 1920s who was the first love of my youth. The figure is her self-portrait. And partly because I have had a lifelong love of nature, and a special fondness for flowers."

EVA 1988

TERRY O'NEILL

HRH THE DUCHESS OF YORK 1988

"This is my favourite photograph because I feel that it captures the great natural beauty, dignity, and fearless spirit of Her Royal Highness. I took it at the request of the Duke and Duchess of York at the South Ocean Studios, Jubilee Place, King's Road, London. My equipment was a Hasselblad with a 120mm lens and five Balcar lights."

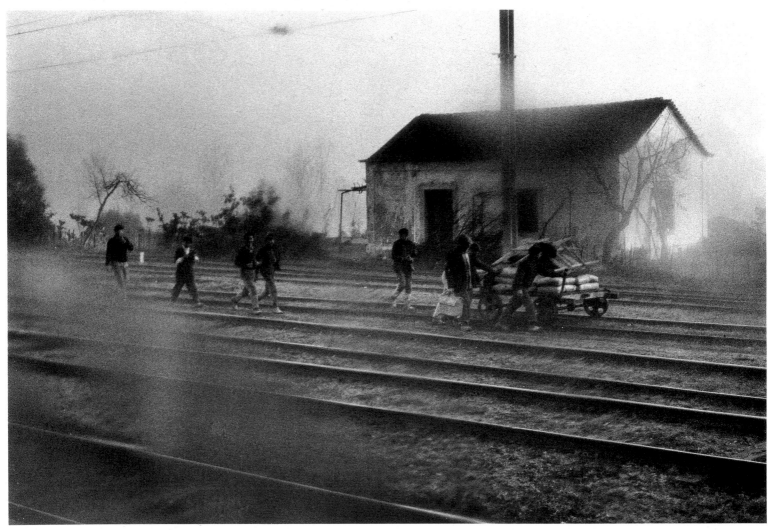

BOYS ON RAILWAY TRACKS 1968

"This photograph was taken from a train
window in Portugal. It is about an illusion of
buoyancy contradicted by a feeling of
vulnerability. The train passed at high speed
and I snapped the contradiction onto my film.
I want to believe these boys remained
untouched, but something tells me they didn't.
I keep going back to this picture in an attempt
to understand what happened."

NEAL SLAVIN

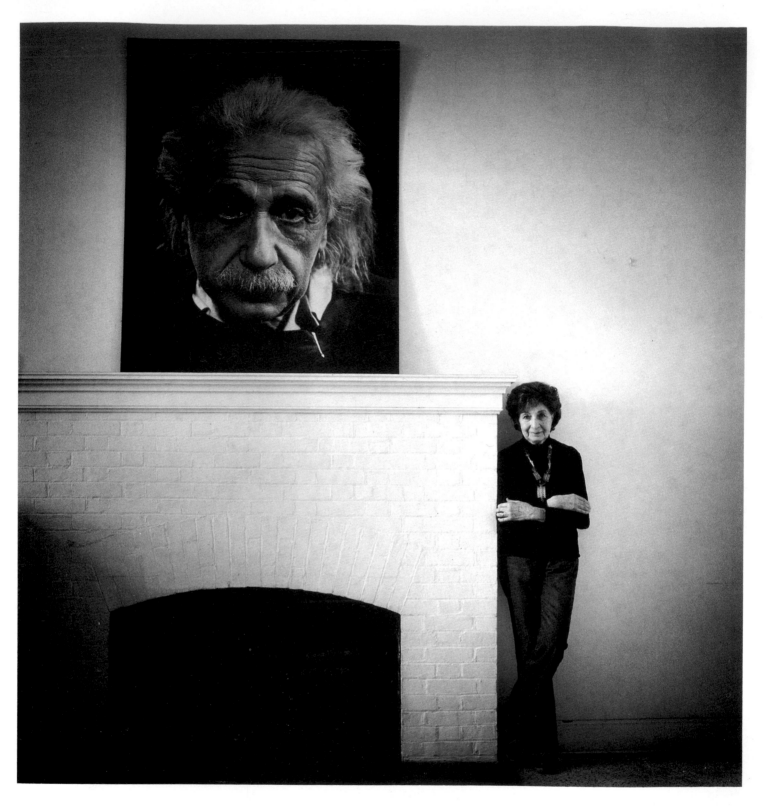

YVONNE HALSMAN

"I was Philippe's wife and assistant for forty-five years, and this is my favourite picture because it shows my husband the way I would like to remember him. Marilyn had just done her jump for the *Life* cover, and Philippe joined her in front of the camera. To make the picture I used strobe lights and put the camera low on the floor. In Fi's portrait of me, the photograph of Einstein above the fireplace was taken by Philippe."

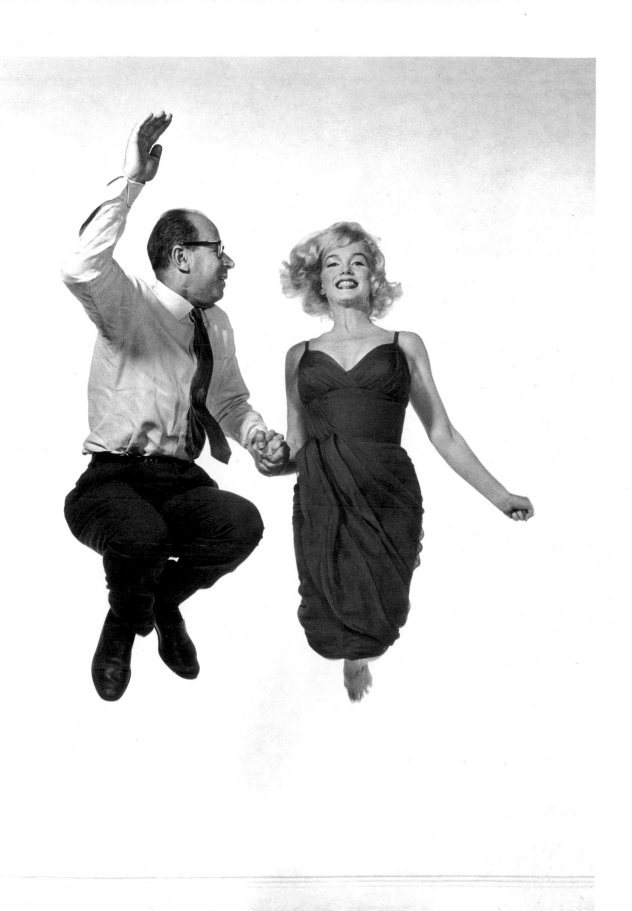

PHILIPPE HALSMAN AND MARILYN MONROE JUMPING 1959

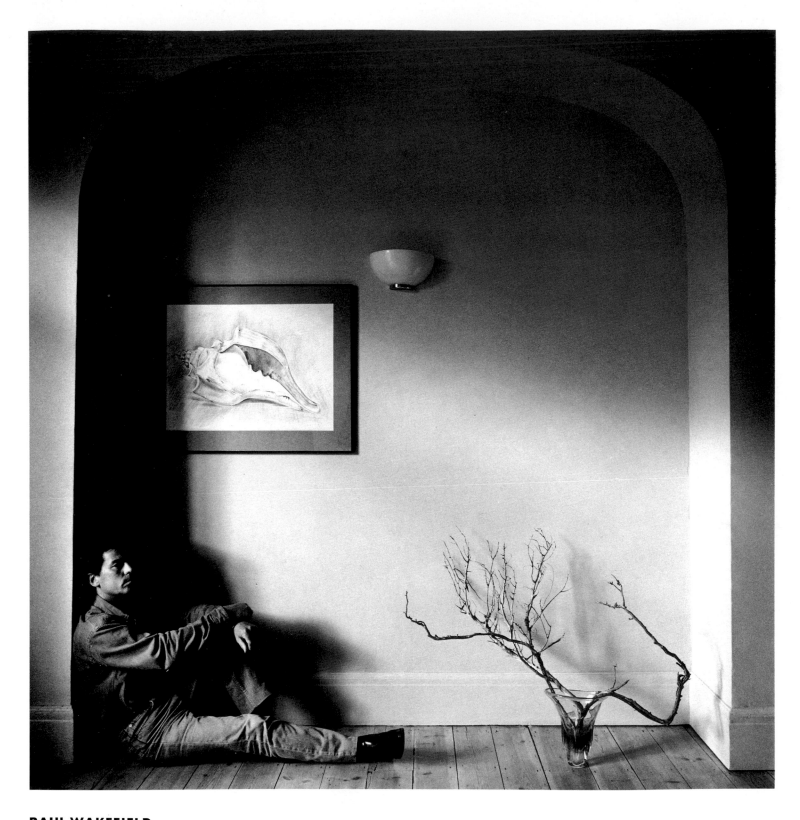

PAUL WAKEFIELD

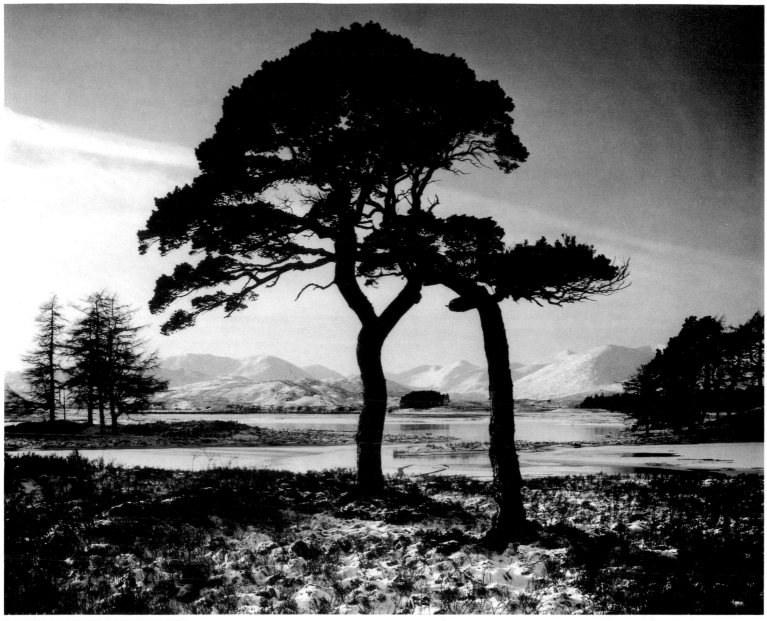

CALEDONIAN PINES, SCOTLAND 1985

"I don't have a favourite photograph but I feel that this image, part of a series on Scotland, is a successful one. I never analyze too closely why I take my pictures. I prefer to work intuitively.

"The photograph was taken in low winter evening light. The balance, with the landscape element and the fall of the light, makes it an ideal composition for me."

HUMPHREY SPENDER

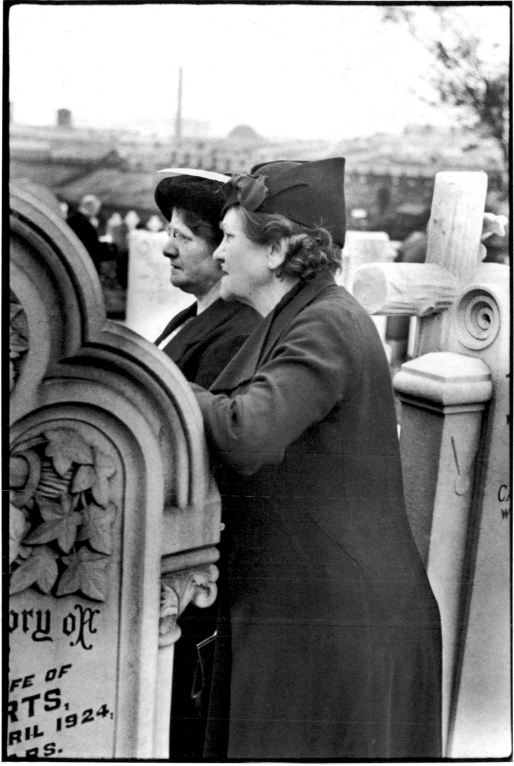

WORKTOWN PEOPLE 1937

"I took this in 1937 for Mass-Observation Bolton, Lancashire. Snatching such pictures with a hidden camera from a hidden position was stressful, inducing guilt about spying and fear of being discovered.

"These women are themselves spying on a burial service. I like the hint of industrial background to the religious event, the hint of enjoyment in the mixed emotions expressed by the faces. The slightly ghoulish hats remind me of the bird people in some paintings by Edward Burra.

"The photograph is from a general coverage of a funeral, one of the targets of Mass-Observation."

HARRY BENSON

"I took this photograph on assignment for *Life* magazine in Atlanta, where Martin Luther King's body was taken for burial. At the airport I stood among the people waiting to see the casket taken off the plane. Dr. King's widow and children came to the door for one moment — the only time they came together in one frame. In the next frame they were gone."

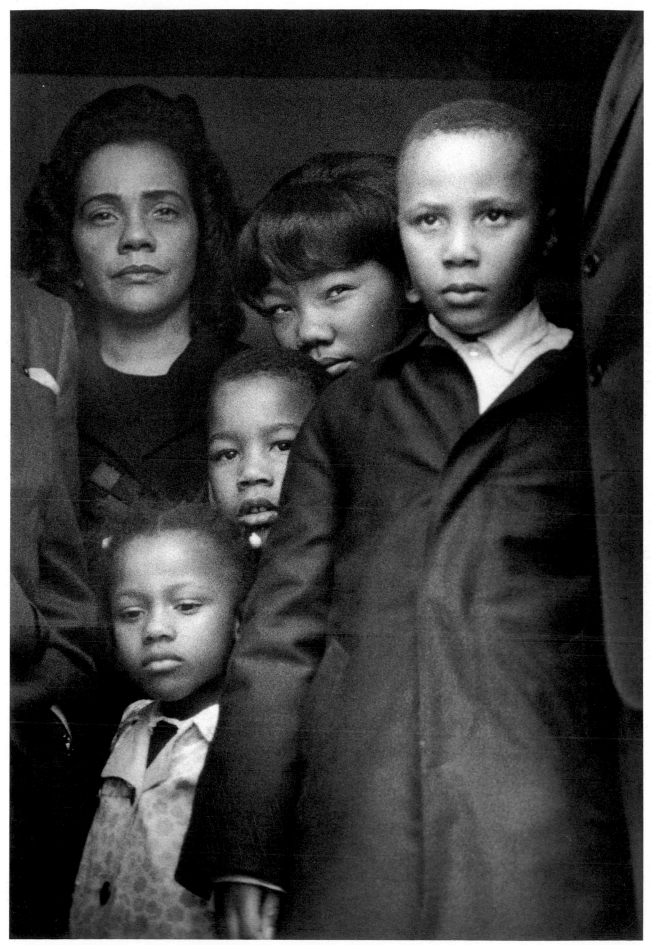

MRS. MARTIN LUTHER KING, JR., AND FAMILY 1968

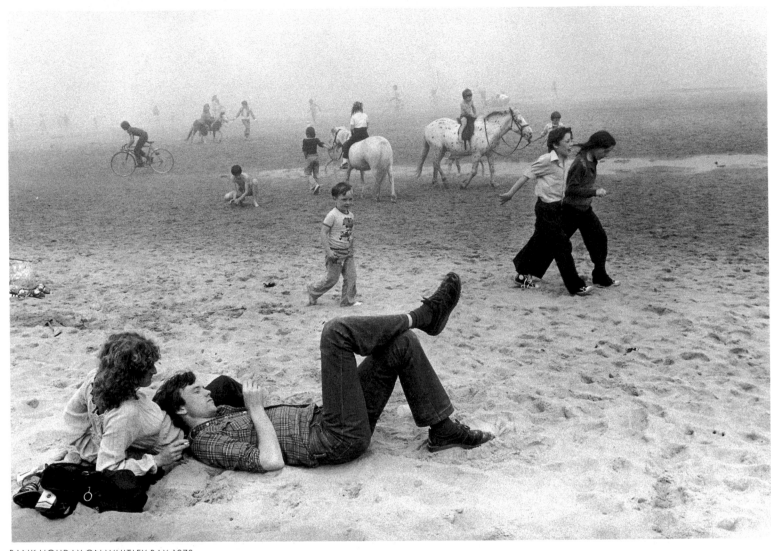

BANK HOLIDAY ON WHITLEY BAY 1978

"This was commissioned by the Side Gallery, Newcastle, but like all my work it is a personal photograph, whatever that means.

"Perhaps it is my favourite because of the day, a warm day that brought in mist from the sea. My son was little and he was toddling between my legs while I was taking the picture. That memory makes the picture a special one for me."

MARKETA LUSKACOVA

ROBERT DOISNEAU

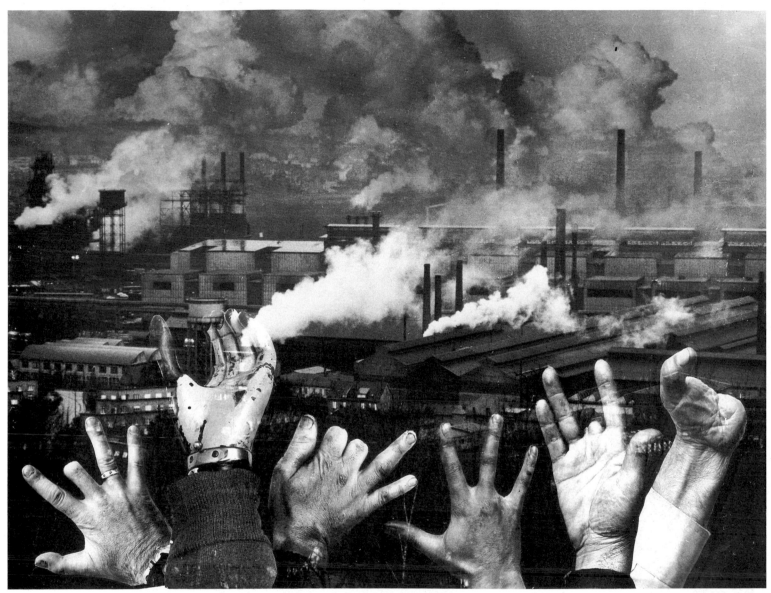

LES MAINS MUTILÉES 1979

"This photograph was taken on commission in Thionville, in the east of France. I have chosen it because it represents a photograph that is just as I would have made it: one that shows dramatically what it is like to work in a factory. It is also a photograph that does not correspond to the expectations that people have of me and of my work."

TONY WITH BLACK FACE 1986

HERB RITTS

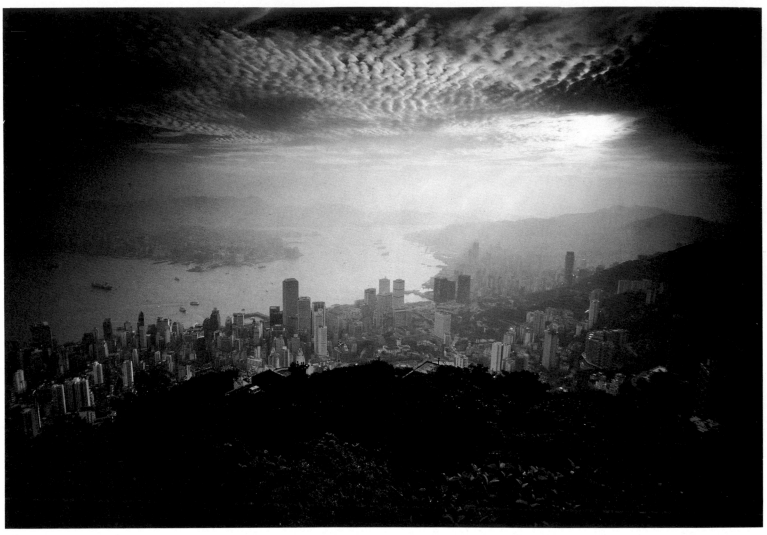

HONG KONG 1980

"I was commissioned by the London advertising agency Collett Dickenson Pearce for a full week's work photographing a series of Army Officer ads in Hong Kong. There was a very full itinerary to get through, but an hour before dawn every day I set out and drove up the serpentine mountain road to The Peak. Once there I set up my camera and waited for my picture. Most mornings were too obscure — Hong Kong is often very humid and misty — but on my final attempt I could see the picture gradually beginning to take shape.

"I like the picture mainly because it's of Hong Kong, which in spite of its more recent inundation by the tourist tide is still, to me, the most romantic place in the world. Maritime history is a passion of mine, so to stand at the top of The Peak and look out over this magical harbour is just a dream for me — I can visualize that same stretch of water a century and a half ago, hundreds of beautiful square-rigged ships of the tea and opium trades.

"The photographic profession carries some rare privileges — this was one of them."

ALAN BROOKING

ARNOLD NEWMAN

"I have many favourites. I chose this one to show what I feel is a successful solution to a difficult problem.

"The picture was commissioned by the National Portrait Gallery in London as part of my series The Great British. I took it at Sir Cecil's Wiltshire home, placing him in his home environment in order to reflect the high-spirited elegance of his own

photographs, set designs and costumes.

"Sir Cecil was lit from either side by French windows with a bit of bounce fill. The crucial element was not to show the almost total paralysis he suffered on his right side from a stroke. I felt he should be presented to show the *joie de vivre* he shared with the world."

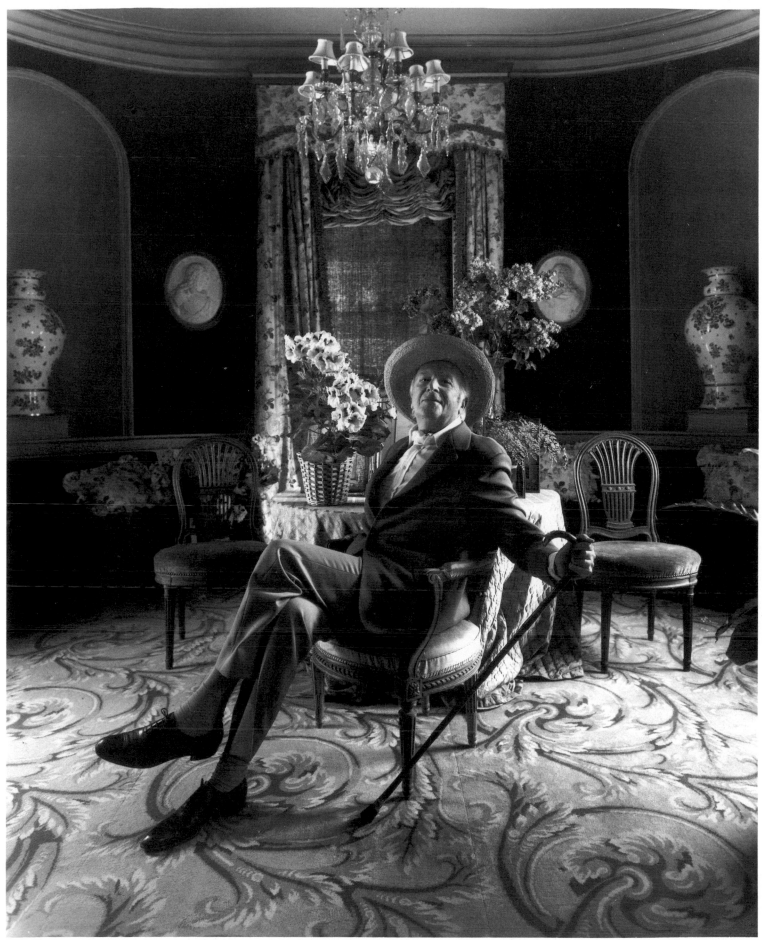

SIR CECIL BEATON 1978

SNOWDON

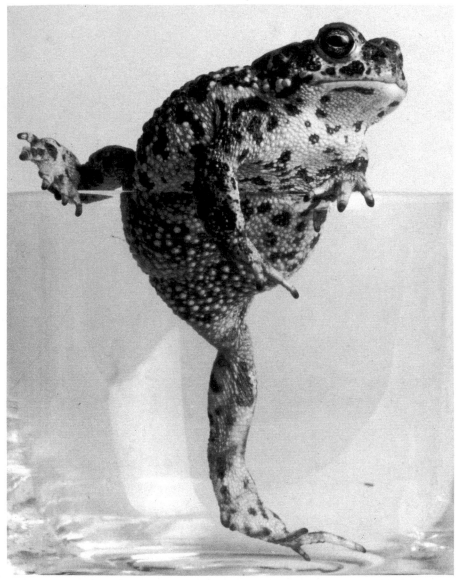

NATTERJACK TOAD, 1986

"This is my favourite photograph because I
like all the others less, and not many
natterjack toads get photographed.
Commissioned by *Vogue* magazine, it was
taken in Sussex."

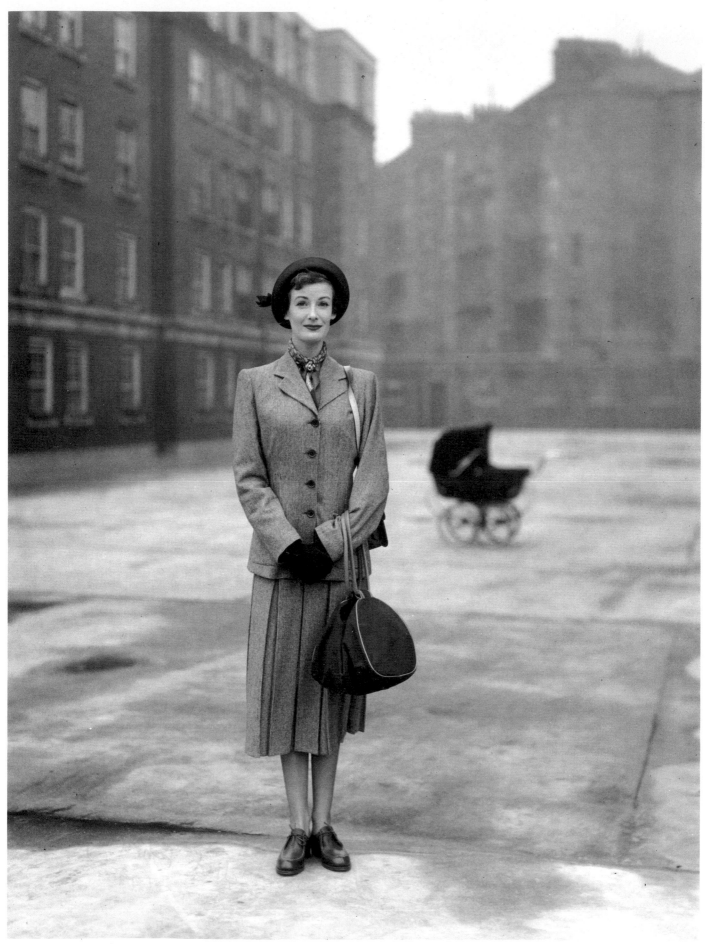

SIMPSONS SUIT, PEABODY TRUST BUILDINGS, FULHAM ROAD 1949

"This is not necessarily my favourite, just the favourite of my peers, so I decided to go along with them in choosing an image for this book. The picture was taken for British *Vogue* to show what a girl would look like wearing an outfit from one year's clothing coupons. It was taken at the Peabody Trust Buildings in the Fulham Road."

NORMAN PARKINSON

died February 1990

KEN GRIFFITHS

112

ROBBI & SON 1987

"I was photographing in Clarendon, Texas, when this truck parked in front of me. I was going to ask the driver to move but changed my mind when I saw this subject. The picture led to me being commissioned for a book about the Texas Panhandle. I like it because it wasn't planned and because it sums up what I feel is important about photography: recording life as it really is."

GRACE ROBERTSON

"This picture reminds me of the two things that most satisfy me as a photographer. On the one hand, I have succeeded in taking a photograph that summarizes precisely what I had hoped to capture: the enjoyment of a particular experience. At the same time, as a photojournalist I valued making my photographs within a spirit of mutual trust. I assumed that the women would behave naturally, and they trusted me not to make them look foolish or present their lives untruthfully.

"I took the picture during one of the numerous stops for 'refreshment' between Battersea and Southend. It is a lively reflection of the friendship and comradeship shared by all the women. These Battersea wives, no strangers to hard work, were intent on squeezing the last drop of pleasure from their day out."

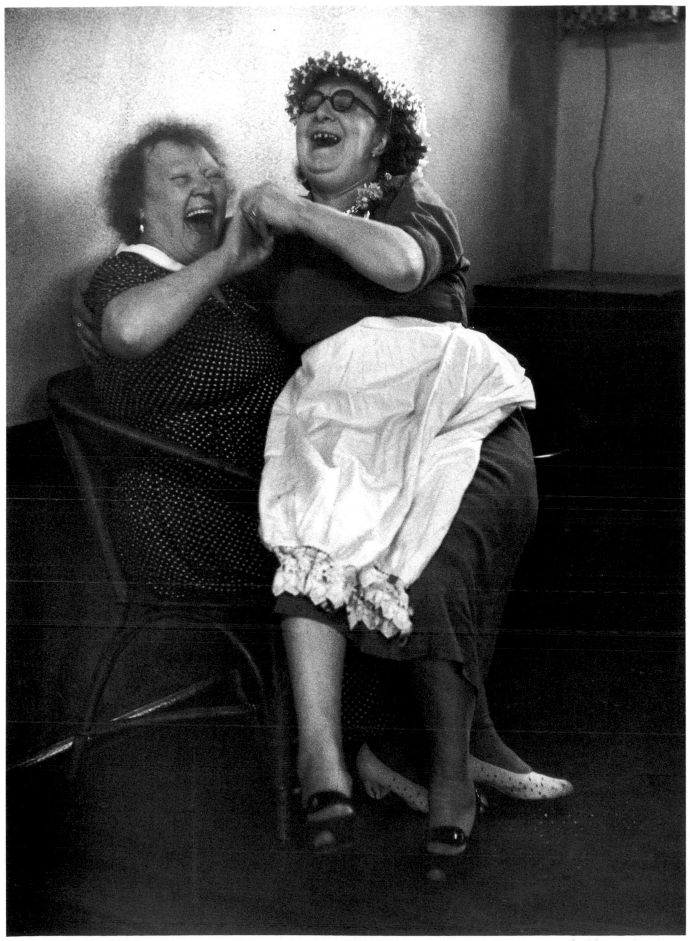

MOTHER'S DAY OFF 1954

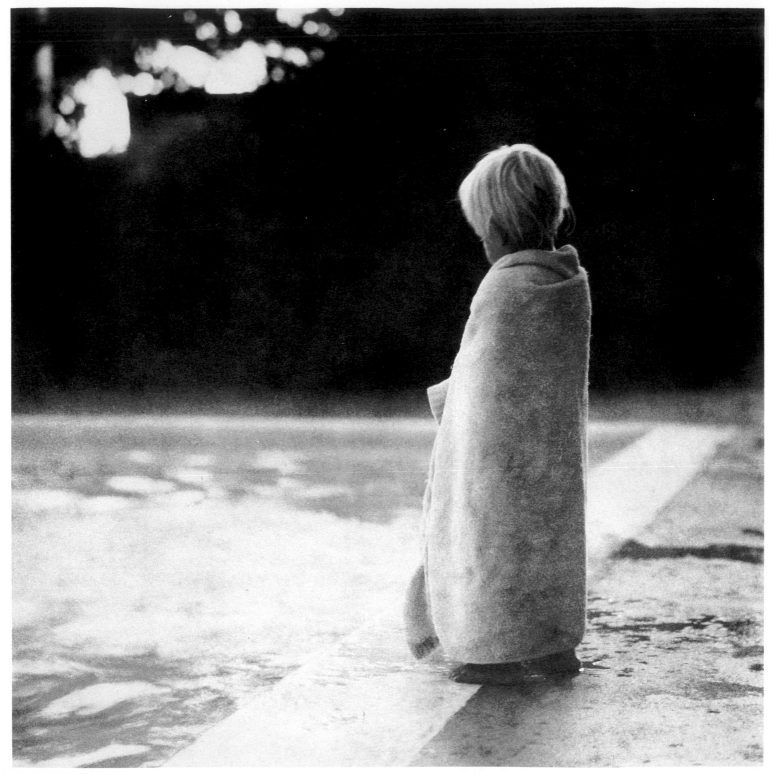

NEVIS CHILD 1987

"The photograph was taken after sunset in Nevis, in the West Indies. I was lucky enough to be standing there with a camera in my hand. I like it because it reminds me of some sort of good childhood — feeling not too warm and not too cold."

ANDREAS HEUMANN

JOHN SWANNELL

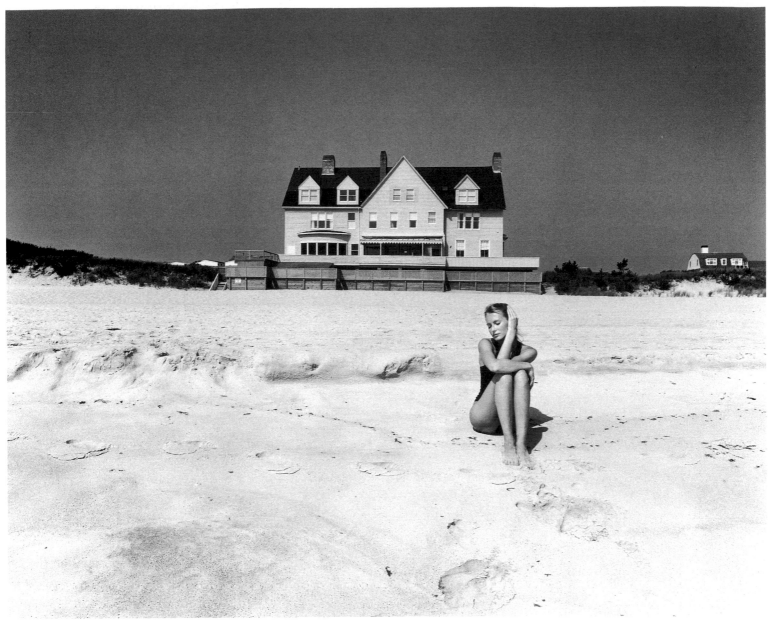

MARIANNE – LONG ISLAND 1985

"This is my favourite picture because the girl is my favourite person and the town of Southampton, Long Island, is one of my favourite places in the world. Some pictures just fall into place, just happen. Everything in this snap was just right — the late afternoon light, the girl, the old traditional beach house in the background. All I did was point the camera."

RENE BURRI

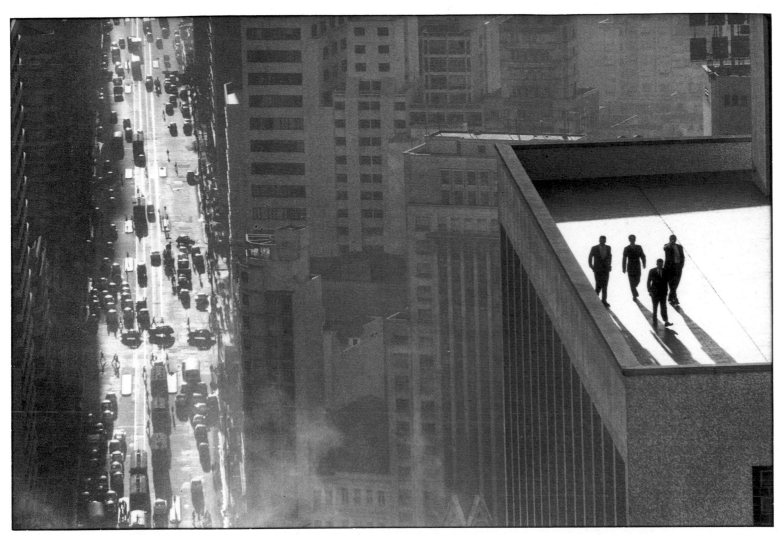

FOUR MEN ON A ROOF, SAO PAULO, BRAZIL 1960

"The photograph I have chosen was taken in São Paulo, Brazil. It is a highly constructed picture. There are four men in black suits who represent the alienation of Man as a symbol in the modern city. This is a fierce image but it is also, at the same time, like *Paradise Lost*. It's like floating through space on a rooftop. An apocalyptic image."

MARY ELLEN MARK

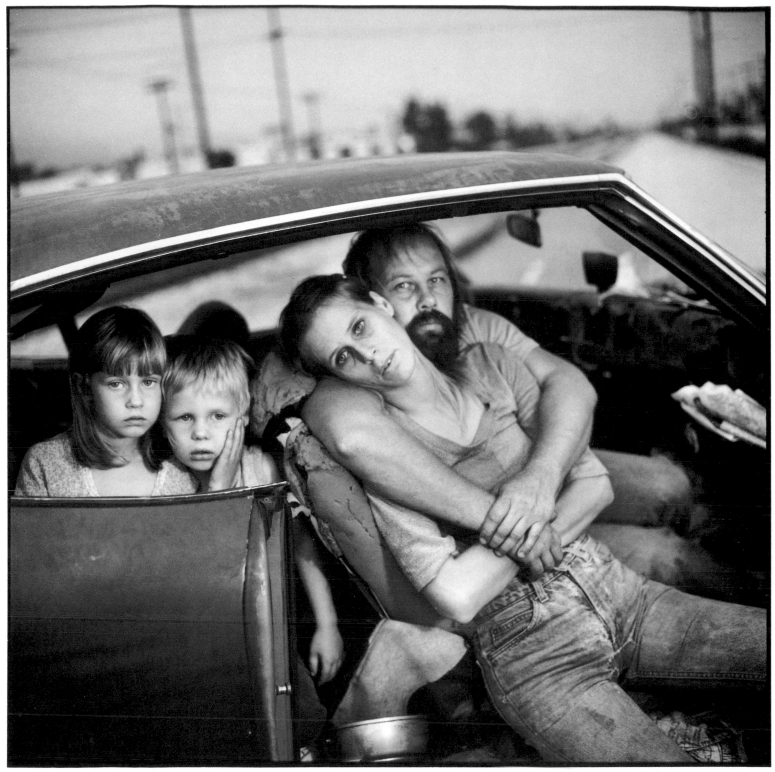

HOMELESS FAMILY IN THEIR CAR 1987

"My recent photographs are always more important to me than earlier ones. And I hope that my favourite photograph next year will be one that I have not yet taken this year.

"This photograph was made in Los Angeles, in the San Fernando Valley, on an assignment for *Life*. It was the opening photograph in the story. I spent one October week with the Damms, a homeless family in California.

"During that week I became very close to and involved with the family, especially the children. I feel that this is a strong representation of how lonely, isolated, and desperate the family felt. I wanted the photograph to move people: I wanted them to see how terrible it is to be homeless. I hope that I have succeeded."

123

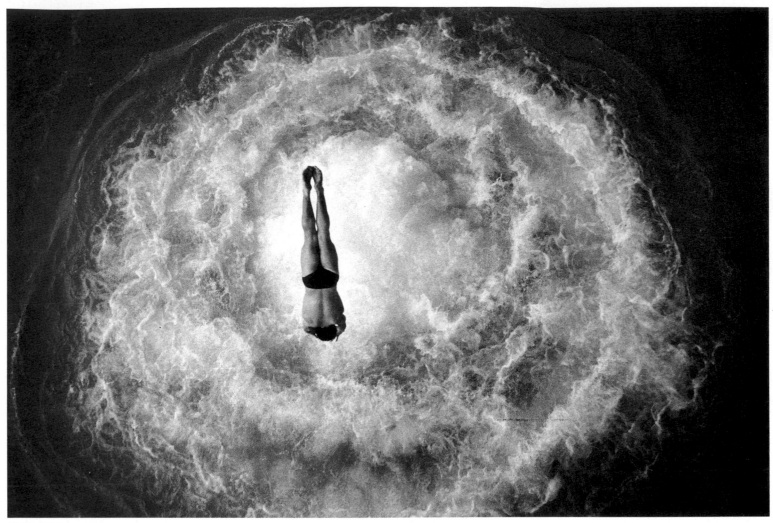

DIVER, CRYSTAL PALACE 1982

"I have chosen this picture because it is an unusual shot of a familiar sport. It was taken on commission for the *Observer*. I had heard that the Diving Team at Crystal Palace were using nitrogen burst to protect their dive, and I was interested in exploring what the picture would look like taken from the top of the diving board."

EAMONN McCABE

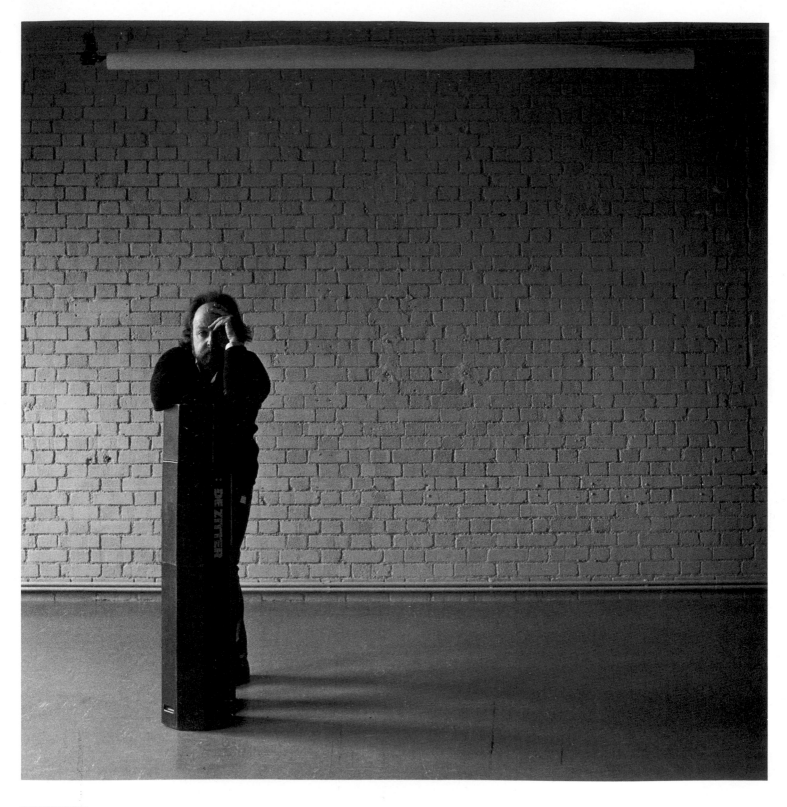

DE ZITTER

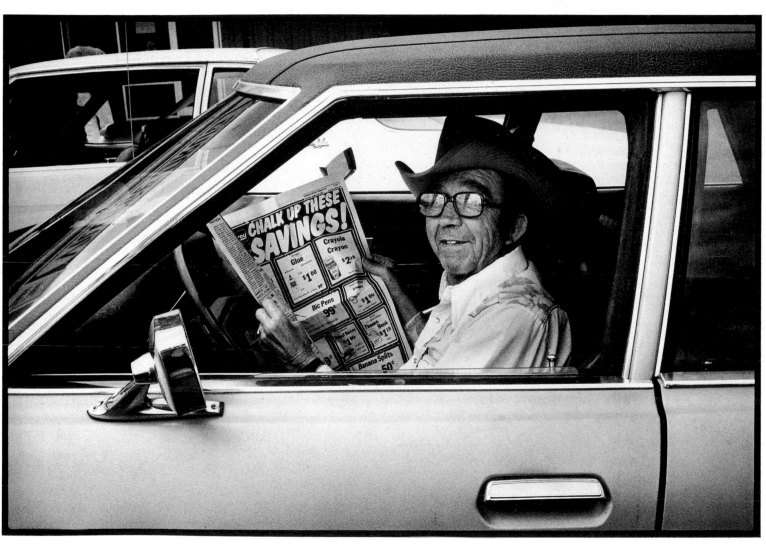

K-MART PARKING LOT, ARIZONA 1987

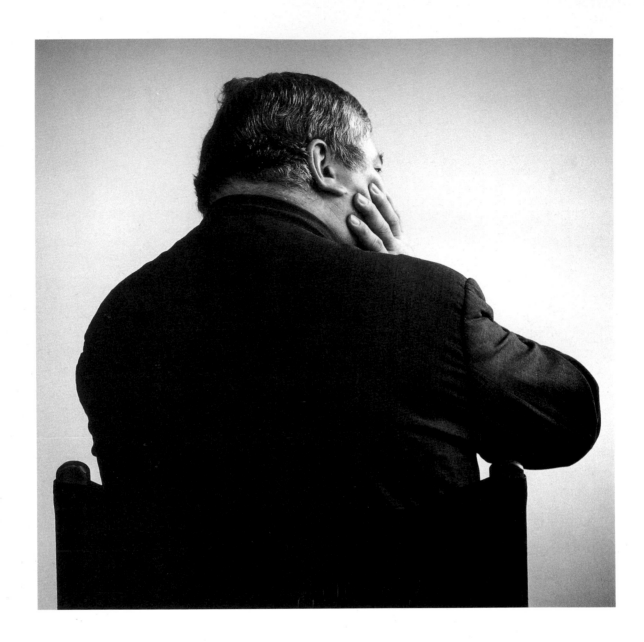

TERENCE DONOVAN

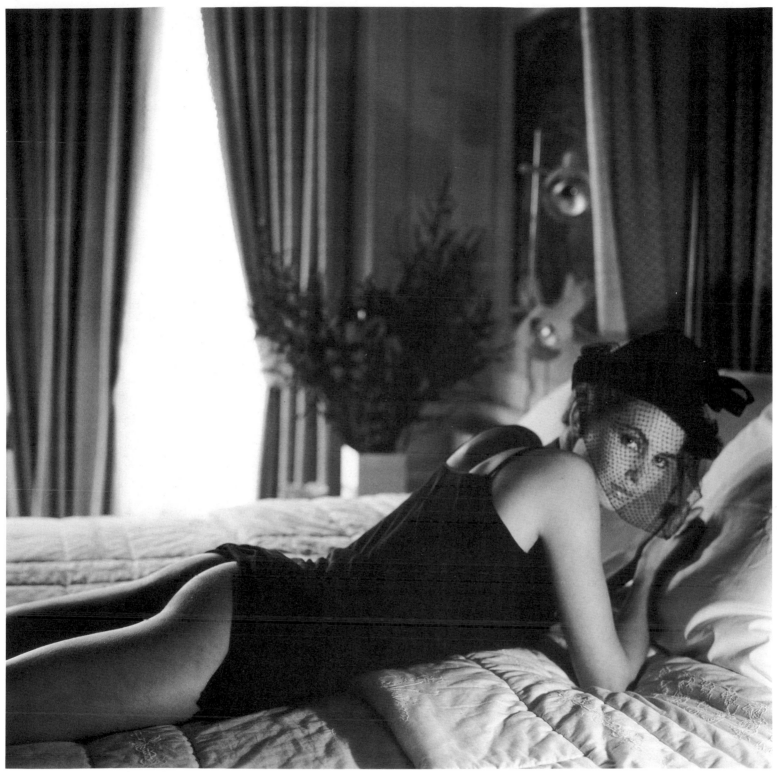

SMART HAT 1983

"I wouldn't say that this was my *favourite* picture — I don't really have a favourite. This one just seems attractive. It was taken for the cover of a book of mine called *Glances* in an ambassador's house in London with a Rolleiflex camera in low-level light aided by various lights. The atmosphere was very quiet and peaceful."

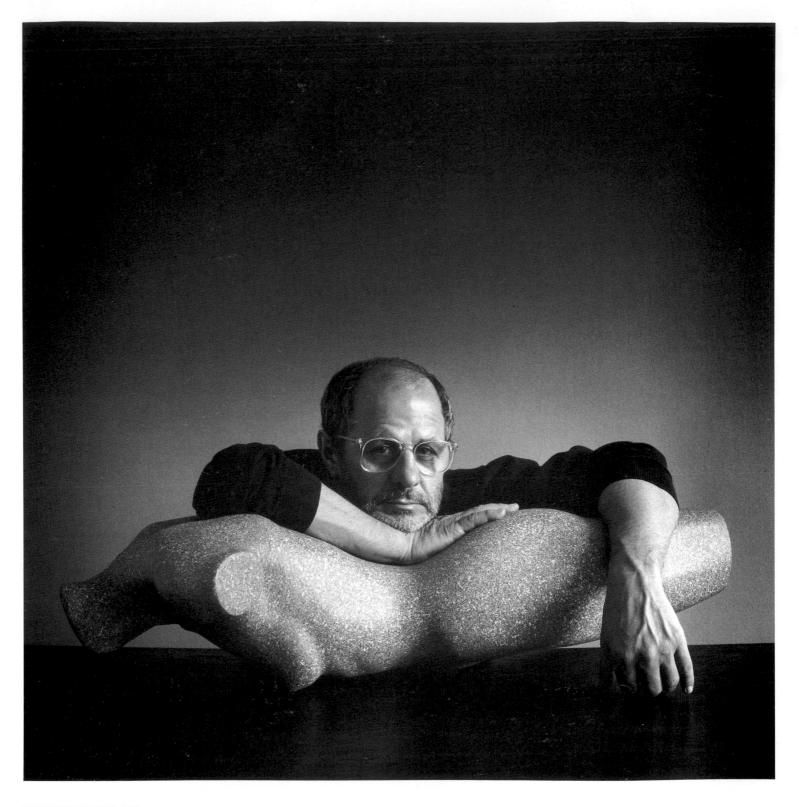

BARRY LATEGAN

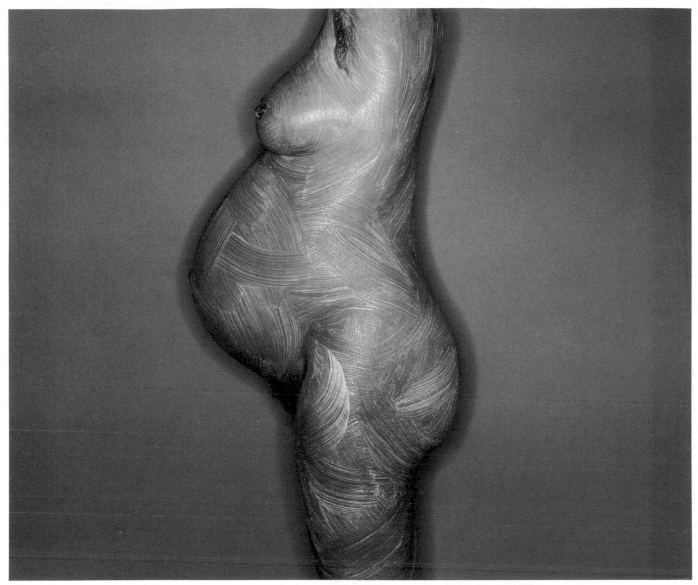

CHARLENE AND DYLAN 1980

"I have chosen this photograph as my favourite because it is a portrait of my son and his unknown future. The mechanical result is what I saw before I took the picture. It is a personal photograph, taken in a studio in New York."

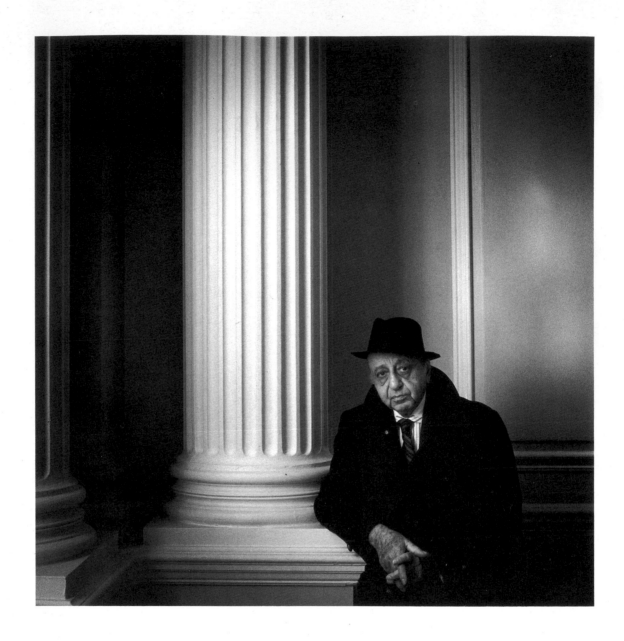

YOUSUF KARSH

"In the Abbey de Cuxa in Prades, I spent several glorious hours with the master of the cello, Pablo Casals. Our rapport was instantaneous; he trusted me to carry his cello into the Abbey. He told me of his uncompromising stance against the Spanish dictatorship of the Franco regime. I was so moved on listening to him play Bach I could

not, for some moments, attend to photography. I have never photographed anyone, before or since, with his back to the camera — but it seemed to me just right. For me, the bare room conveys the loneliness of the artist, at the pinnacle of his art, and also the loneliness of the exile.

"Years later when my portrait of Casals taken from the back was on exhibition at the Museum of Fine Arts in Boston, I was told that

an elderly gentleman would come and stand for many minutes each day in front of it. When the curator, by this time full of curiosity at this daily ritual, ventured to tap the old man on the shoulder and gingerly inquired, 'Sir, why do you come here day after day and stand in front of this portrait?' he was met with a withering glance and the admonition, 'Hush, young man, hush — can't you see, I am listening to the music!'"

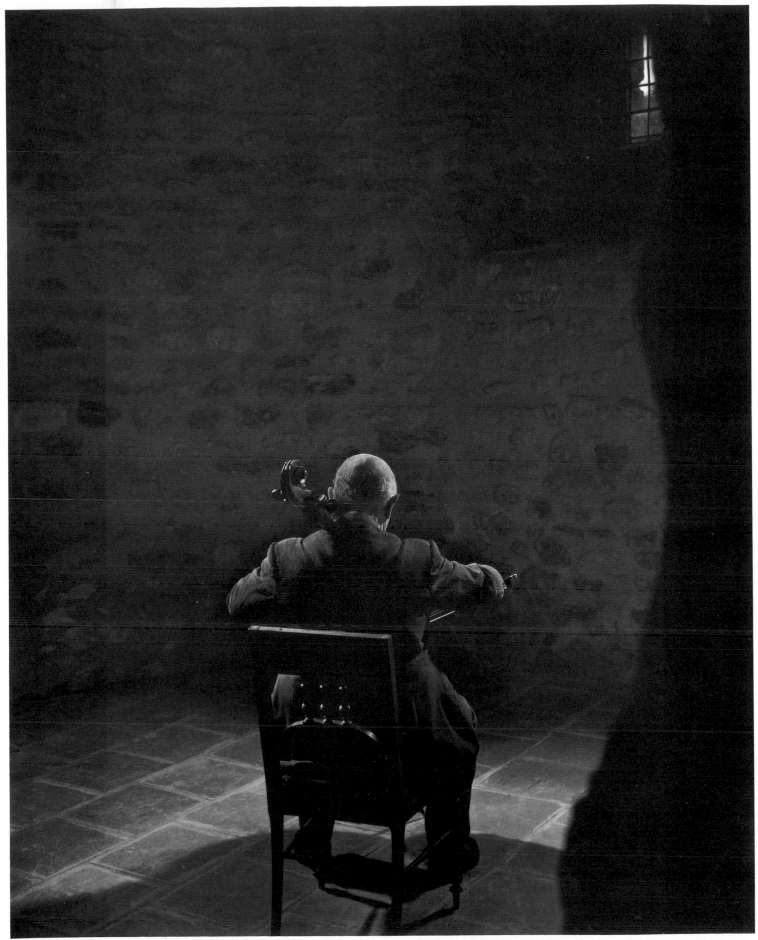

PABLO CASALS 1954

BIOGRAPHIES

CLIVE ARROWSMITH
Clive Arrowsmith was born in north Wales "at a very early age." He moved to London when he was 19, spending seven years in art schools studying painting and graphics. He then became an art director in television, and started taking photographs for his own advertisements. He has never been an assistant, and is photographically self-taught. He received his first *Vogue* commission in 1970, shooting covers, fashion portraits, and still life, and he has since worked on all the major beauty and fashion campaigns on both sides of the Atlantic, including a Dunhill fashion campaign. "I have just achieved one of my life's ambitions," he said in May 1988, "having a private audience with His Holiness the Dalai Lama and photographing him. I am planning a book of landscapes and Buddhist temples in northern India, in between advertising and editorial commissions." Clive Arrowsmith lives in London.

HARRY BENSON
Harry Benson was born in Glasgow, Scotland, in 1929. He worked as a photographer for *The Hamilton Advertiser*, a weekly newspaper, and later for daily papers in London. In 1964 he went to the United States for the London *Daily Express* and now lives in New York City. Benson's work was first published in *Life* magazine in 1968 and continues to appear in many magazines, including *People, Fortune, Time, New York,* and *Vanity Fair*, as well as *Life*. He is the author of one book, *Harry Benson on Photojournalism* (1982), and his work has been exhibited at galleries and museums in Britain and the United States. Harry Benson has received many awards for his photography, including the ASMP Magazine Photographer of the Year award on two occasions.

EDOUARD BOUBAT
Edouard Boubat was born in France in 1923. Introduced to photography at a trade school, he later worked as a photographic technician. After World War Two he began photographing for himself and, with encouragement from Picasso, left full-time employment to pursue his work. For 15 years, from 1951 onwards, he was closely associated with the French magazine *Realités*, and he has travelled widely doing reportage photography. Among his books are *Woman* (1973) and *La Survivance* (1976). Edouard Boubat's works are held by several collections including the Museum of Modern Art, New York, and the Bibliothèque Nationale. He lives and works in Paris.

JANE BOWN
Jane Bown was born in England and served with the WRENS during World War Two. After the war she enrolled on a full-time photography course at the Guildford College of Art, the first course of its kind in Britain. After graduating she took on portrait commissions, starting with commissions from friends. Not long afterwards she received her first commission from the *Observer* and in 1950 joined the paper as a staff photographer. She has worked for the *Observer* ever since, specializing in editorial portraiture, but she also did some fashion work in the 1960s. Jane Brown was made an MBE in 1984 and has published three books: *The Gentle Eye* (1980), *Women of Consequence* (1986) and *Men of Consequence* (1987). She lives in Hampshire, England.

ALAN BROOKING
Alan Brooking was born in Australia. He has worked in the advertising industry for more than 40 years, spending 20 of those as an art director. Her worked for the London agency Collett Dickenson Pearce for five years in the 1960s. Alan Brooking left CDP in 1967 to work as an advertising photographer and since then has been involved with a large number of well-known campaigns. Based in London, he has won numerous awards for his work.

DAVID BURNETT
David Burnett was born in the United States in 1946 and has worked as a photojournalist since the 1960s. He has received many awards for his work, including Photographer of the Year (National Press Photographers Association) and Best Reporting from Abroad (Overseas Press Club of America). David Burnett is the founder of the Contact Press photo agency. He lives in New York.

RENE BURRI
René Burri was born in Zurich in 1933. He studied photography and film-making at the *Kunstgewerbeschule* in Zurich but is largely self-taught in the field of photojournalism. In 1954, after serving in the Swiss Army, he became a freelance photojournalist and has had work published in many major magazines, including *Life, Look, Stern*, the *Sunday Times, Paris-Match,* and *Geo*. He has also worked as a film-maker since 1954, and since 1959 has been a member of Magnum. He received an International Film and Television Award and has exhibited in both the United States and Europe. Among the many public collections that contain his work are the Bibliothèque Nationale, Paris, and the Art Institute of Chicago. His books include *The Gaucho* (1968) and *In Search of the Holy Land* (1979). René Burri lives in Zurich.

CORNELL CAPA
Cornell Capa is a photographer, author, editor, and founder and director of the International Center of Photography in New York. A member of the *Life* magazine staff from 1946 to 1954, he continued as a contributing photographer until 1986 through his association with Magnum, the photographers' cooperative. His work focused on such social issues as old age and retarded children, on major religions, American politics, and various Latin American subjects. Capa has photographed for and edited a number of books, among them *The Concerned Photographer* (1966), *ICP Encyclopedia of Photography* (1984), *Adlai Stevenson's Public Years* (1966), *Farewell to Eden* (1964), and *Margin of Life* (1974). Among his numerous distinctions, in 1975 he was elected to the honour roll of the American Society of Magazine Photographers for "great and lasting contributions made to photography." Cornell Capa is the younger brother of the late Robert Capa.

BOB CARLOS CLARKE
Bob Carlos Clarke was born in County Cork, Ireland, in 1950. On leaving school he worked as a journalist for the *Daily Express* in Ireland and also for an advertising agency. In 1970 he went to study graphics at the West

Sussex College of Art, where he became involved in photography, and later received an MA from the Royal College of Art. He has worked since then as a photographer both on advertising assignments and on personal projects, and has directed television commercials; his advertising clients have included Levi's, Smirnoff, and Pirelli. He has exhibited his work at Hamilton's Gallery and the Whitechapel Gallery in London, and his work has been published all over the world in such magazines as *Vogue, Tatler,* and *Stern.* Bob Carlos Clarke has published three books: *The Illustrated Delta of Venus* (1980), *Obsession* (1981), and *Dark Summer* (1985). He lives in London.

JOHN CLARIDGE

John Claridge was born in the East End of London. He became interested in photography when he was about 10, photographing the East End in a self-generated photography project. After leaving school he went to work for the advertising agency McCann Erickson and had his introduction to advertising photography, a field in which he has become a leading figure. John Claridge has exhibited worldwide, having had his first one-man show at the age of 17, and has won more than 150 awards for his work. Throughout his career he has also pursued personal projects, including his work in the East End, and a series of photographs of jazz musicians. He has published two books: *South American Portfolio* (1982) and *One Hundred Photographs* (1987). John Claridge is based in London.

LOUISE DAHL-WOLFE

Louise Dahl-Wolfe was born in San Francisco in 1895. She studied painting at art school and worked as a decorator and designer before becoming interested in photography through the works of Anne W. Brigman, the American pictorialist. Formally untrained, Dahl-Wolfe worked in San Francisco in the early 1930s taking photographs for a decorating firm. In 1933 she moved to New York, where one of her pictures was published in *Vanity Fair.* Refusing an offer from *Vogue* to work in their studios, she freelanced as a fashion photographer until 1936, when she was hired by *Harper's Bazaar* to do still lifes and later portraiture as well as fashion work.

Working closely with editor Carmel Snow and fashion editor Diana Vreeland, she produced boldly innovative work for well over a decade. Louise Dahl-Wolfe left *Harper's Bazaar* in 1958 and, after working briefly for *Vogue,* gave up fashion photography altogether. She lives in New Jersey.

DAWID

Dawid was born in Orebro, Sweden in 1949. One of the leading younger photographers in Sweden today, he has exhibited his work in numerous one-man shows at museums and galleries in Sweden. He has also exhibited in France, Germany, and elsewhere in Europe, and his work was included in The Frozen Image: Scandinavian Photography (1982) at the Walker Art Center in Minneapolis, Minnesota. Dawid has published seven books of his work, including *Rost* (1983), *Dawid* (1980), and *9 × 12/4 × 5* (1982). A major monographic issue of the magazine *Picture-Show* has recently been devoted to his work. He lives in Stockholm.

ROBERT DOISNEAU

Robert Doisneau was born in Gentilly, a suburb of Paris, in 1912. He took up photography in the 1930s after seeing the work of Brassaï, and worked as a photographic assistant on books and in advertising and fashion while taking reportage photographs of Paris. Later in the decade, after military service, he took a job as an industrial photographer for the Renault factories at Billancourt, where he worked for about five years. In 1939 he began to sell his work through the Agence Rapho. During World War Two he served for a time with the French Army and in the post-war period, after doing minor work for women's magazines, he became associated again with the re-formed Agence Rapho. From 1950—51 he worked for *Vogue* in the United States and later published photographs in *Life, Picture Post,* and other major magazines. Robert Doisneau's most famous work has been carried out in France, especially Paris. His books include *1,2,3,4,5* (1955), *My Paris* (1972), and *Un Certain Robert Doisneau* (1986). He has said: "I hate factories, and when I see one I make a great detour around it just so that I don't have to go inside." Robert Doisneau lives in Montrouge, France.

TERENCE DONOVAN

Terence Donovan was born in London in 1936 and began his career in photography when he was 15 years old. He worked as assistant photographer for Michael Williams, John Adrian, and John French before he became a military photographer. At the age of 22 he set up his own studio and has worked for a number of magazines, including *Vogue, Elle, Marie Claire, Harper's & Queen,* and *Cosmopolitan.* In the course of his career in photography and television commercials he has visited some 72 countries. He has 3,000 commercials to his credit and has directed "The Clive James Paris Fashion Show" for London Weekend Television. Terence Donovan has also produced plays for CBS, including *Early Days* with Sir Ralph Richardson and *The Importance of Being Earnest* with Dame Wendy Hiller. More recently he has worked as a director of music videos; his video for Robert Palmer's "Addicted to Love" was voted Best Male Video for 1985 by MTV. Terence Donovan lives in London.

JAY DUSARD

Jay Dusard was born in the United States in 1937. He received a 1981 Guggenheim Fellowship for his work in photography, which led to the publication of *The North American Cowboy: a portrait* (1983). He is represented in the collection of the Center for Creative Photography in Tucson, Arizona. His second book, *La Frontera: The United States Border with Mexico* (1986), with text by Alan Weisman, received the 1988 Four Corners Book Award for Non-Fiction. Jay Dusard lives in Prescott, Arizona.

ALFRED EISENSTAEDT

Alfred Eisenstaedt was born in Germany in 1898. Given his first camera at the age of 14, he began work as a freelance photojournalist for the Associated Press in 1929. In 1935 he emigrated to the United States, settling in New York and later adopting American citizenship. He became one of the first staff photographers for *Life* in 1936, and he was to work for the magazine more or less exclusively until it ceased weekly publication in 1972. Alfred Eisenstaedt is one of the pre-eminent figures in photojournalism; his work includes some of the most famous images in the history of photography. His

many books include *Witness to our Time* (1966), *Eisenstaedt's Album* (1976), and *Eisenstaedt – Germany* (1981). In 1961 he was presented with the 1,000,001st Leica manufactured by Ernst Leitz of Germany and used it to make the official portrait of President John F. Kennedy. His many awards and honours include the Photographer of the Year Award from the University of Missouri School of Journalism (1951), and the Lifetime Achievement Award of the American Society of Magazine Photographers (1978).

ELLIOTT ERWITT

Elliott Erwitt was born in France in 1928 and moved to the United States when he was 11 years old. He became interested in photography as a teenager living in Hollywood. A few years later he moved to New York and quickly established himself as an important figure in magazine photography. His work in photojournalism, illustration, and advertising has been published in numerous magazines in the United States and Europe. He has directed television commercials and documentaries, and has produced television films for CBS and HBO. Elliott Erwitt's books include *Photographs and Anti-Photographs* (1972) and *Son of Bitch* (1974). His work has been exhibited all over the world, including one-man shows at the Museum of Modern Art (New York) and the Smithsonian Institute (Washington, D.C.), and will feature in a major retrospective (with accompanying monograph) in Paris, Cologne, and Tokyo during the autumn of 1988.

HANS GEDDA

Hans Gedda was born in Stockholm in 1942. A leading photographer in his native Sweden, he began his career as an assistant to the portrait and fashion photographer Rolf Winquist. *Bakom Kulisserna* (*Behind the Scenes*), a book of his circus photographs, was published in 1982. He also participated in The Frozen Image: Scandinavian Photography (1982) at the Walker Art Center in Minneapolis, Minnesota. His work has appeared in leading Swedish newspapers and magazines and in such international magazines as French *Vogue, Modern Photography* (United States) and *Photo* (Germany). Hans Gedda lives in Stockholm.

RALPH GIBSON

Ralph Gibson was born in Los Angeles, California, in 1939. He studied photography in the US Navy (1956–60) and at the San Francisco Art Institute (1960–61), and worked as an assistant to the American photographer Dorothea Lange. Gibson's early work was in the reportage tradition pioneered in the United States by Robert Frank (his friend and mentor), but later he moved towards a greater concern with abstraction. He has published a number of books, both under his own Lustrum Press imprint and with other publishers. His recent book *Tropism* (1987) accompanied a major retrospective mounted by the International Center of Photography in New York. His work has appeared in other group and one-man exhibitions all over the world, and is also in the permanent collections of numerous museums. Ralph Gibson's many awards include three National Endowment for the Arts Fellowships and one Guggenheim Fellowship. He also received *Officier de L'Ordre des Arts et des lettres* from the French Government. He has written of his work: "I embrace the abstract in photography and exist on a few bits of order extracted from the chaos of reality." Ralph Gibson lives in New York.

KEN GRIFFITHS

Ken Griffiths was born in New Zealand in 1945. He attended the Royal College of Art from 1969–71, graduating with distinction, and in 1971 was awarded the *Sunday Telegraph Magazine* Young Photographer of the Year Award. His work has appeared in newspapers and magazines including the *Observer*, the *Telegraph, Vogue, Life, Geo, Stern,* and *Vanity Fair*. He was also contracted until 1985 to the *Sunday Times*, for which he travelled extensively on major assignments. Advertising clients for whom he has worked include numerous major corporations, among them IBM and BP. His work has been exhibited at many London galleries, including the Barbican Centre and the Gulbenkian Gallery, and is in the collection of the Victoria and Albert Museum. He has published two books, *The English-woman's Wardrobe* (1986) and *The Panhandle* (1987), and has taken portraits for Amnesty International. Ken Griffiths lives in London.

CHAD HALL

Chad Hall was born in the United States in 1926. He "slid into photography" as a means of supporting his family while working for a PhD in Intellectual History at Columbia University, New York. His first job, as an editor and drama critic, was with *The Nation* magazine. As a professional photographer he has carried out fashion, illustration, and reportage assignments for numerous magazines including *Esquire, Vogue, Harper's Bazaar, Stern,* and *Elle*. Involved in film-making since 1972, he has directed television commercials and documentaries, including *Leni Riefenstahl* (1974), and is a director with Making Movies, a television commercial production company. Chad Hall moved to Europe in the mid-1960s. He has won numerous awards from the Art Directors Clubs in New York, London, and Germany, and his photographs have been exhibited in the United States and in Europe. He lives in London.

YVONNE HALSMAN

Yvonne Halsman was born in France but has adopted US citizenship. She assisted and worked with her husband Philippe Halsman throughout his career in freelance portrait and magazine photography. He had 101 *Life* magazine covers to his credit, more than any other photographer. Halsman was also famous for his "jump" photographs, in which he had his portrait sitters jump in the air! "In a jump," Halsman said, "you cannot control your expression, you jump in your own character. The mask falls and you become your real self." Yvonne Halsman's image in this book is a photograph that uses Philippe's "jump" approach. Yvonne Halsman lives in New York.

BERT HARDY

Bert Hardy was born in London in 1913. Self-taught in photography, he worked as a messenger and lab assistant for Central Photo Services, London, from 1927–36. In 1939 and 1940 he worked as a photographer for the William Davis Agency in London and contributed work to *Illustrated London News* and *Tatler*, among other publications. During World War Two he served as a photographer in the army. Bert Hardy's most famous work was done while he was a staff

photographer on *Picture Post*, a job he held until 1957. After leaving *Picture Post* he became a freelance advertising photographer and in 1960 founded the Grove Hardy photo lab. Bert Hardy has received four *Encyclopedia Britannica* Awards and the 1951 Unifoto Gold Medal. Among his books are *Bert Hardy: Photojournalist* (1975) and *Bert Hardy: My Life* (1985). In 1987 Channel 4 broadcast a television documentary about him, *Bert Hardy's World*. He has exhibited widely in Britain, and lives in Surrey.

ANDREAS HEUMANN

Andreas Heumann was born of Swiss parents in Germany in 1946. Educated in Switzerland, he later trained in blockmaking and printing. In 1969 he moved to London, where he took up photography, doing fashion work for such magazines as *Twen, Harper's & Queen*, and *Vogue*. During the next decade he moved away from fashion photography to concentrate more on advertising, and he has photographed campaigns for IBM, Timex, and Lanson Champagne among other clients. Andreas Heumann has received many awards for his work, including AFAEP Awards for four consecutive years (1984–87) and the New York Art Directors Award in 1987. He lives and works in London.

THURSTON HOPKINS

Thurston Hopkins was born in London in 1913. He studied magazine illustration at Brighton College of Art from 1931–33, and from 1936–37 worked as a photographer for the Photopress Agency in London. During World War Two he served as a photographer with the Royal Air Force. From 1946 to 1950 he freelanced as a photojournalist and in 1950 became a staff photographer for *Picture Post*, where he remained until 1957. From 1959 to 1968 he was a freelance advertising photographer in London. Thurston Hopkins lectured at the Guildford School of Photography (now part of the West Surrey College of Art) from 1969–77. His book, *Thurston Hopkins*, was published in 1977, and his work is in public collections in Britain and Europe. He lives in East Sussex with his wife Grace Robertson, who is herself a highly regarded photographer. She also features in this book.

HORST

Horst was born in Hamburg, Germany, in 1906. He studied architecture in Hamburg and worked in Paris under Le Corbusier before a meeting with Dr. Agha, art director of American *Vogue*, led him to experiment with photography. In the late 1920s he turned to photography full-time. From 1932 to 1935 he lived in Paris and worked as a fashion photographer in the studios of French *Vogue*. From 1935 he travelled regularly to New York working for American *Vogue*; when war broke out in 1939 he emigrated to the United States and has lived in New York ever since. A naturalized American citizen since 1942, he spent the war in America, joined the US Army in 1943, and attained the rank of sergeant in the Combat Engineers. Horst's long association with *Vogue* produced some of the most influential fashion work of the 1930s and 1940s; his innovative use of lighting was particularly important. He also photographed interiors for the magazine and has worked extensively in portraiture. His books include *Patterns from Nature* (1946), *Horst: his work and his world* (1984), and *Salute to the Thirties* (1971), the success of which has led to his current book project, *Salute to the Eighties*. In 1988 Horst received the Lifetime Achievement Award from the Council of Fashion Designers of America. Horst is still active as a photographer. He lives in New York.

FRANK HORVAT

Frank Horvat was born in Abbazia, Italy (now Yugoslavia), in 1928. Self-taught, he took up photography in 1944. After studying drawing in Milan (1948–49), he worked as a graphic artist in Milan advertising agencies before becoming a freelance photographer in 1951. His many clients have included *Paris-Match, Picture Post, Life, Harper's Bazaar*, and *Esquire*. In 1956 he moved to Paris, where he worked for the Black Star Agency, and in 1957 he took up fashion photography. Horvat was one of the first photographers to bring the 35mm "reportage" style to fashion photography. Frank Horvat's work has been exhibited widely and is in numerous collections in the United States, Europe, and Britain. His books include *Strip-Tease* (1962) and *The Tree* (1979). Frank Horvat lives in Boulogne, near Paris.

ART KANE

Art Kane was born in the Bronx, New York, in 1925. He attended New York public schools and studied graphic design at Cooper Union from 1946–50. He later studied photography with Alexei Brodovipch at the New School in New York. From 1942–45 he served with the US Army in Europe and from 1950–59 worked as a designer and art director, first with *Seventeen* magazine and then with *Esquire* and the Irving Serwer Advertising Agency. In 1959 he turned to freelance photography, in which he has continued to work with great distinction apart from two years as Corporate Design Director for *Viva*. His photographs have appeared in many major magazines, including *Look, Life*, and *Vogue*. His books include *The Persuasive Image: Art Kane* (1975), *The Emotions of Color* (1976), and *Paper Dolls* (1985). Art Kane lives in New York.

YOUSUF KARSH

Yousuf Karsh was born in Mardin, Armenia-in-Turkey in 1908. He went to live with his Uncle Nakash in Canada in 1924, and after attending school briefly he went to work as an apprentice in the Boston studio of portrait photographer John H. Garo. Karsh set up his own studio in Ottawa in 1932 and quickly acquired widespread recognition for his portraiture. In 1941 he made his "bulldog" portrait of Winston Churchill, which made him world-famous. He has remained one of the most renowned photographers in the world, and 14 of his portraits have been used on postage stamps. He has travelled extensively and his sitters include many of the 20th century's most famous figures. Yousuf Karsh's work is represented in major museums and public collections all over the world, and he has received a long list of awards and accolades including honorary degrees from over a dozen colleges and universities. His books include *Portraits of Greatness* (1950), *Karsh: A Fifty-Year Retrospective* (1983), and his autobiography *In Search of Greatness* (1962). Yousuf Karsh travels the world from the Ottawa studio he has operated for more than 50 years.

WILLIAM KLEIN

William Klein was born in New York in 1928. In 1948 he was discharged from the US Army

in Paris, where he worked with painter Fernand Léger and experimented widely in painting, graphic design, and photography. He returned to New York in 1954 to do a photographic journal on the city, and in 1955 began a ten-year contract with American *Vogue*. After eight months Klein returned to Europe. His book *New York* (1956) won the 1957 Prix Nadar. It was later followed by books of photographs made in Rome, Moscow, and Tokyo in the 1950s and 1960s. Six monographs of his work have been published in the 1980s. Klein's work in fashion, abstract, and street photography was highly innovative and influential. In 1963 an international jury at the Cologne Photokina voted him one of the 30 most important photographers in the history of the medium. In 1965 he gave up professional photography to work on films, and he wrote and directed ten feature films. In 1980, however, he returned intermittently to photographic activities. William Klein was awarded the Grand Prix Nationale de la Photographie in France in 1986 and the Guggenheim in 1988. His photographs have been exhibited all over the world and are represented in numerous major collections. He lives in Paris.

BARRY LATEGAN

Barry Lategan was born in South Africa in 1935. He says of his beginnings in photography: "I was trained and taught all I know by Ginger Odes, in Cape Town, South Africa, who started me in professional photography with the words 'You're a lucky person if your work is also your hobby' in reply to my asking him 'What will I do for a hobby if I take on a job with you?'" Lategan began working for Ginger Odes in 1959. Between 1961 and 1966 he was a photographic assistant in various studios in London and in 1967 opened his own studio. Since 1977 he has worked primarily in New York and is now based in London. His photographs have been widely published in magazines and exhibited all over the world; he is the recipient of numerous honours including British and American television awards, photo awards from AFAEP and the 1988 Halina Award (Photographers Gallery). Barry Lategan published a portfolio of trees in 1981 and is currently preparing a book of nudes.

JOHN LOENGARD

John Loengard did his first photographic assignment for *Life* in 1956, when he was an undergraduate at Harvard, and joined the *Life* staff five years later. His best-known essays for the magazine include "The Shakers" (1967) and "The Vanishing Cowboy" (1970). When *Life* ceased weekly publication Loengard became Picture Editor of Time, Inc.'s Magazine Development Group. He was first Picture Editor of *People* magazine, and Picture Editor for the ten Special Reports published by *Life* between 1973 and 1978, including the famous "One Day in the Life of America" (1974). He served as Picture Editor of the monthly *Life* from its launch in 1978 until 1987, and one of his essays for the magazine, "Photographers Born in the 19th Century," won the 1982 University of Missouri award for Best Magazine Picture Story. Loengard writes a monthly column in *American Photographer* and teaches photography in New York. His book, *Pictures Under Discussion* (1987), won the Ansel Adams Award for Book Photography given by the American Society of Magazine Photographers.

CORNEL LUCAS

Cornel Lucas was born in London. He began his career in photography at the age of 14 and studied photography at the Regent Street and Northern Polytechnics. In 1937 he went to work in the film industry as a trainee lab technician. During World War Two he worked on reconnaissance and public relations in the RAF, and on returning to the film industry worked first for Denham Film Studios and later for Pinewood Studios. From 1946—59 he worked as a portrait photographer in film studios including Rank, Columbia, Universal, and Twentieth Century-Fox. He left the film industry in 1959 to open his own studio in Chelsea, concentrating on advertising and editorial work. More recently he has turned again to portraiture. Cornel Lucas still operates from his Chelsea studio. He has exhibited his work widely and has won numerous photographic awards, and his first book, *Heads and Tails*, is to be published shortly. He lives in London.

MARKETA LUSKACOVA

Markéta Luskačová was born in Prague and studied sociology at Karlove University. After graduating in 1967 she turned to photography and studied at Prague's Academy of Film and Arts (1967—69). Admission to the Czech Artists' Union gave her the chance to pursue freelance professional work, and she had considerable success, but in 1975 she left Czechoslovakia to settle in London. Luskačová now works as a photojournalist and pursues personal projects as well. She has received grants and commissions from the Arts Council and the Side Gallery (Newcastle), and her work is in the collection of the Victoria and Albert Museum, among others. Markéta Luskačová was the subject of a monographic issue of *Creative Camera* magazine in 1987.

ANGUS McBEAN

Angus McBean was born in Newbridge, Monmouthshire, in 1904. Self-taught in photography, he worked as a bank clerk in Wales and at Liberty's in London before getting a job as an assistant in the London studio of photographer Hugh Cecil. In 1934 he opened his own studio, specializing in theatrical photography and publishing his work in *Sketch* and elsewhere. He took "front of house" photographs for many of the most important theater companies in Britain, including the Old Vic and Sadlers Wells, and was Britain's leading theatrical photographer for 30 years. Some 48,000 glass negatives of this work are now owned by Harvard University Library. He is perhaps best known, however, for the distinctive Surrealist-influenced portraits he took in the 1930s and 1940s for *Sketch* and *Tatler*. Angus McBean's work has been exhibited worldwide and is in numerous collections in the United States, Europe, and Britain. His book *Angus McBean* was first published in 1984 and was recently reissued. A new book of his photographs of Vivien Leigh, *Vivien: A Love Affair in Camera*, is in preparation. He lives in Debenham, Suffolk.

EAMONN McCABE

Eamonn McCabe was born in London in 1948. He began taking photographs as a rock and roll photographer while in his early 20s, and worked as a freelancer selling his pictures to North London newspapers for about seven years. From 1976 to 1977 he worked on *The*

Guardian as a general news photographer. Since 1977 he has worked on the *Observer*, specializing in sport photography. Eamonn McCabe is now universally acknowledged as one of the pre-eminent figures in that field, receiving the Sport Photographer of the Year on four occasions and the News Photographer of the Year once. He has published two books: *Eamonn McCabe: Sport Photographer* (1981) and *Eamonn McCabe: Photographer* (1987). He considers himself a photographer who covers sport rather than a sport photographer, and recognition of his wider achievement came when he was made the 1988 Fellow in Photography, National Museum of Photography. Eamonn McCabe lives in London.

MARY ELLEN MARK

Mary Ellen Mark received a BFA in painting and art history from the University of Pennsylvania (1962), and an MA in Photojournalism (1964) from the Annenberg School of Communications of the same university. Since beginning work as a photojournalist in the 1960s, she has established herself as one of America's foremost figures in the field. Her work has appeared in leading newspapers and magazines in the United States, Europe, and Britain, and has been exhibited widely both in one-woman and group shows. Mary Ellen Mark has received grants from the Fulbright Foundation and the National Endowment for the Arts. Her numerous awards include the Leica Medal of Excellence (for her 1981 series Falkland Road) and the Robert F. Kennedy Journalism Award for her *Life* essay on Mother Teresa in Calcutta. She lectures and gives seminars at workshops and museums, and has published several books of her work, including *Passport* (1974), *Ward 81* (1979, and *Falkland Road* (1981). She lives in New York.

WAYNE MILLER

Wayne Miller was born in the United States in 1918. He served during World War Two as a naval combat photographer in the unit headed by Edward Steichen and has received two Guggenheim Fellowships for his studies of The Way of Life of the Northern Negro. Wayne Miller worked as an assistant to Edward Steichen in preparing and

mounting The Family of Man (1955) at the Museum of Modern Art, the most widely seen exhibition in the history of photography. He has carried out numerous assignments for magazines and has published two books, *Baby's First Year* with Dr. Benjamin Spock and *The World is Young*. He is a member and past president of Magnum Photos Inc. Wayne Miller lives in Orinda, California, where he and his family have operated a Redwood/Douglas fir forest since 1958.

ARNOLD NEWMAN

Arnold Newman was born in New York City in 1918. He attended schools in New Jersey and Florida and studied art at the University of Miami, in Florida, from 1936 to 1938. Newman took up photography in 1938 and in 1941 went to New York, where he developed the "environmental portraiture" for which he is best known. His 1945 exhibition, Artists Look Like This, attracted considerable attention and his career as an editorial portraitist became well established. He has worked for many of the most important magazines in the United States, including *Life, Look,* and *Town and Country,* and has also done work for corporate clients including Eastman Kodak and Polaroid. Newman is one of the best known portrait photographers in the world: his environmental approach has been a powerful influence in contemporary photography and has been celebrated in dozens of exhibitions. Among his many awards and honours is the American Society of Magazine Photographers Life Achievement Award (1975). His many books include *One Mind's Eye* (1974), *The Great British* (1979), *Artists: Portraits from Four Decades* (1980), and *Arnold Newman: Five Decades* (1986). Arnold Newman lives in New York.

TERRY O'NEILL

Terry O'Neill was born in London in 1938. He became a professional jazz musician at the age of 14, working in London clubs, and turned to photography when he was 20. After spending four years working on the London *Daily Sketch* he became a freelance photographer. Terry O'Neill now travels extensively as one of the world's leading photographers specializing in celebrity portraiture. Magazines in which his images

have appeared include *Life, Look, Stern,* and *Paris-Match*. A book of his portraits, *Legends,* was published in 1985. Terry O'Neill is based in London.

NORMAN PARKINSON

Norman Parkinson was born in London in 1913. From 1931—33 he served an apprenticeship with the court photographers Speaight and Sons, London, and in 1934 opened his own studio. Up until World War Two he sold his work to the British *Harper's Bazaar* and to *The Bystander*. During the war he worked in reconnaissance for the Royal Air Force. From 1945—60, as a fashion and portrait photographer for *Vogue*, Norman Parkinson was one of the leading exponents of greater spontaneity and naturalness in fashion photography. He also took up advertising photography from 1952 onwards and worked for the picture magazine *Queen* from 1960—64. Since 1960 he has been freelancing for *Vogue, Life, Elle,* and other publications. He received the Lifetime Achievement Award from the American Society of Magazine Photographers in 1983 and the Hasselblad Gold Medal in 1985; in 1980 he was made a CBE. Norman Parkinson's books include *Sisters Under the Skin* (1978) and *Lifework* (1984). Still active as a photographer, he lives in Tobago.

JOHN PHILLIPS

John Phillips, a United States citizen, was born in Algeria in 1914. Educated in Algeria and France, he was hired as a photographer by *Life* in the year of its founding (1936) and worked for the magazine for the better part of two decades. His travels for *Life* took him all over the world to a total of 52 countries, and he served as a war correspondent in the Middle East, Yugoslavia, and Italy. He is the author of six books, including *The Italians: Face of a Nation* (1965) and *It Happened in our Lifetime* (1985), and has contributed to a number of others. In addition to *Life*, the magazines that have published his work include *Paris-Match, Esquire, Stern,* and *Connoisseur*. His work is in the permanent collections of the Metropolitan Museum of Art (New York) and the Bibliothèque Nationale (Paris), among others, and has been exhibited widely in the United States and Europe. John Phillips lives in New York.

HERB RITTS

Herb Ritts was born in Los Angeles in 1952. He studied economics at Bard College, Annandale, New York, and took up photography for his own interest. The first pictures he sold were of the actor Richard Gere, a friend of his. From their success followed other portraits of actors, a field in which he has continued to work. He also photographs for album covers and works in fashion photography and advertising. Most of his fashion work is done for the Condé Nast organization in the United States and abroad. Among the other publications publishing his work are *Rolling Stone, Interview,* and *LA Style*. Herb Ritts' photographs have been exhibited in Los Angeles and as part of a show of contemporary American photography organized by the Whitney Museum in New York. A book of his work, *Herb Ritts' Pictures,* has recently been published.

GRACE ROBERTSON

Grace Robertson was born in England in 1930. Between 1949 and 1957 she worked as a photojournalist for *Picture Post* magazine, travelling on assignment in Britain and Europe. In addition to her work for *Picture Post,* she carried out assignments for other magazines, including *Life*. She was also involved in teaching from 1966 to 1979. Grace Robertson was included in the major exhibition Women Photographers in Britain 1900–1950 and in the book *Women Photographers: The Other Observers, 1900 to the present,* by Val Williams (1986). She was also the subject of a television film in 1986. She is a lecturer and a contributor to *Creative Camera* magazine. She lives in East Sussex, England with Thurston Hopkins, her photographer husband.

WILLY RONIS

Willy Ronis was born in Paris in 1910. Educated there, he served as a meteorologist with the French Air Force in 1931 and again in 1939–40. A freelance photographer since 1936, he has been based in Paris and has received numerous awards for his work. Among them are the Kodak Prize (1947), the Gold Medal at the Biennale, Venice (1957), the Grand Prix National des Arts et Lettres (1979), and the Prix Nadar

(1981). In 1986 he was made a *Commandeur dans l'Ordre des Arts et Lettres*. Willy Ronis has taught off and on since 1968. He has exhibited widely in Europe and the United States, and is generally regarded as one of the foremost 20th-century French photographers. His works are in the collections of the Museum of Modern Art and Metropolitan Museum (New York) and the Bibliothèque Nationale (Paris), among many others. His books include *Belleville-Menilmontant* (1954), *Sur le Fil du Hasard* (1980), and *Mon Paris* (1985). Willy Ronis lives in Paris.

EVA RUBINSTEIN

Eva Rubinstein was born of Polish parents in 1933 in Buenos Aires while her pianist father was on a concert tour. The family lived chiefly in Paris until 1939, when they emigrated to the United States; they became US citizens in 1946. Eva Rubinstein attended Scripps College in California and the theater department of UCLA. After a period of dancing and acting on the New York stage, she married a church minister and had three children. In 1967 she took up photography and studied with Lisette Model, Jim Hughes, Ken Heyman, and Diane Arbus. Two portfolios and two monographs of Rubinstein's work have been published, and she has had numerous one-person and group shows in the United States and Europe. Her work is represented in the collections of museums, universities, and libraries including the Metropolitan Museum of Art, New York, the Museum of Modern Art of the City of Paris, the Bibliothèque Nationale and the Museum of Modern Art in Stockholm. She teaches extensively and has most recently received a Hoyt Fellowship from Yale University, New Haven, Connecticut. Eva Rubinstein is based in New York, but travels extensively.

JEANLOUP SIEFF

Jeanloup Sieff was born in Paris in 1933. He studied photography in Paris and Vevey, Switzerland, from 1953–54. A professional photographer since 1954, he worked as a fashion photographer for *Elle* from 1955–58. After a year in the army he joined Magnum, which he left in 1960 to go freelance. From 1961–65 he spent time in New York, where

his work was published in *Glamour, Look, Harper's Bazaar,* and other publications. On returning to Paris he established his own studio, and has continued to work for magazines and on advertising commissions both in photography and in television, as well as pursuing personal work. Among Jeanloup Sieff's awards are the *Prix Niépce* in 1959 and a Silver Medal from the Advertising Film Festival, Cannes, in 1975. He has published several books, including *La Danse* (1961) and *Death Valley* (1978). Jeanloup Sieff lives in Paris and had an important exhibition in 1986 at the Museum of Modern Art.

NEAL SLAVIN

Neal Slavin was born in Brooklyn, New York, in 1941. He studied painting, graphic design, and photography at Cooper Union from 1959–63. A freelance photographer since 1970, his work has appeared in many magazines and newspapers including the *New York Times,* the *Sunday Times, Stern,* and *Life*. In 1974 he established his own studio in New York and began to teach photography at colleges and universities. Neal Slavin was awarded a Fulbright Photography Fellowship in 1968 and received grants from the National Endowment for the Arts in 1972 and 1976. He was chosen as Corporate Photographer of the Year in 1987 by the American Society of Magazine Photographers. His books include *Portugal* (1971) and *When Two or More Are Gathered Together* (1976). His book and exhibition *Britain: 1986* arose out of a commission from the National Museum of Photography, Film and Television in Bradford. Neal Slavin lives in New York.

CHRIS SMITH

Chris Smith was born in Hartlepool, County Durham, in 1937. At the age of 16 he joined the staff of a local evening newspaper as a darkroom assistant and trainee photographer, and worked there for a total of five years (interrupted by two years National Service). He then moved to London and became a Fleet Street photographer, working as a staff photographer on the *Daily Herald* and the *Observer* before joining the *Sunday Times,* where, for 11 years, he has been specializing in sport. Chris Smith's press

awards for his work include Press Photographer of the Year, News Photographer of the Year, and Sport Photographer of the Year on four different occasions. His book *Sport in Focus* was published in 1987. Chris Smith lives in Richmond, Surrey.

SNOWDON

Snowdon was born Antony Armstrong-Jones in London in 1930. He studied architecture at Jesus College, Cambridge, from 1948–50 and worked as a photographic assistant to the London studio photographer Baron from 1950–51. Since 1951 he has been a freelance photographer based in London, and has published his work in numerous magazines and newspapers including *Life* and *Vanity Fair*. He has worked for many years as a regular photographer for *Vogue* and the *Sunday Times*. Snowdon is a film-maker as well as a photographer; his nine documentary films include *Don't Count the Candles* (1968), which received two Emmy Awards, and *Born to be Small* (1971). His numerous books include *Sittings 1979–1983* and *Stills 1984–1987*, and he has exhibited his work widely. Snowdon is based in London.

SALLY SOAMES

Sally Soames became involved with photography in 1959, when she borrowed a camera to take holiday pictures in Paris. Her career began in 1960, when pictures she took in Trafalgar Square on New Year's Eve won an *Evening Standard* competition for amateur photographers. Following that success she gained freelance assignments from newspapers and magazines including the *Observer, The Guardian,* and the *Sunday Times*. In 1968 she joined the *Sunday Times* as a staff photographer. Sally Soames is the recipient of a Kodak Fine Arts Award (1986) and has had one-woman exhibitions in New York and London. Her book *Manpower* was published in 1987. Sally Soames lives in London.

HUMPHREY SPENDER

Humphrey Spender was born in London in 1910 and studied at the Architectural Association from 1929–34. Though primarily self-taught in photography he learned a great deal from his brother Michael, who

worked for Ernst Leitz, makers of the Leica camera. Spender opened his own studio in London in 1934. A leading figure in 20th-century British documentary photography, he was a staff photographer from 1936–38 (under the name "Lensman") for the *Daily Mirror*. From 1937–39 he also worked for Mass-Observation, an organization founded in 1937 as a large-scale exercise in popular sociology that used volunteer observers to gather information on life in England. One study focused on Bolton, Lancashire, which Mass-Observation called Worktown. After the *Daily Mirror* he joined *Picture Post* as a staff photographer and worked there from 1938–41. During World War Two he served as a photographer and as a photo-interpreter. After the war he returned to *Picture Post* but left the magazine in 1949 and largely gave up photography for painting and textile design. He has exhibited his work widely and from 1953–75 taught at various institutions, including the Royal College of Art. Humphrey Spender's books include *The Cotswolds* (1950, *Britain in the 1930s* (1977), *Worktown People: Photographs from Northern England, 1937–38* (1981), and "Lensman": Photographs 1932–52 (1987).

BERT STERN

Bert Stern was born in Brooklyn, New York, in the early 1930s. When he was 17 he got a job in the mailroom of *Look* magazine and became an assistant to art director Herschel Bramson. Later he worked as art director of a small magazine for which he began taking photographs, and after serving in the US Army as a cameraman (1951–53), he took up photography full-time. Soon after, he photographed an immensely successful advertising campaign for Smirnoff vodka, and quickly became one of the most famous advertising photographers in America. After 1959, when he began working for American *Vogue*, Stern concentrated more on editorial and fashion photography. He made *Jazz on a Summer's Day* (1958), a film on the Newport Jazz Festival, and in 1961 began making television commercials. After a period of relative inactivity, he has now moved back to fashion and editorial photography. Bert Stern lives in New York.

JOHN SWANNELL

John Swannell was born in England in 1946. After leaving school at the age of 16 he became an assistant at the Vogue Studios in London, and left there to become an assistant to photographer David Bailey. He worked for Bailey for four years before setting out on his own, specializing in fashion and beauty photography. His work has appeared in magazines that include English, German, and Italian *Vogue, Harper's & Queen,* and *Tatler* as well as in newspapers including the *Sunday Times*. More recently he has moved into directing television commercials and has made more than 30; his first commercial for Boots No 7 make-up won gold awards in London and New York, and at the Cannes Film Festival. John Swannell has published two books: *Fine Lines* (1982) and *Naked Landscape* (1986). He lives in London.

OTMAR THORMANN

Otmar Thormann was born in Graz, Austria, in 1944. After an early career as a chef, he moved to Stockholm in 1965, where he worked as a cook. While working on a round-the-world voyage of the M/S Kungsholm he made a 45-minute film called *Voyage to the South Seas*. In 1968 he began taking still photographs, and studied in the evenings at the Stockholm School of Photography. The following year he became an assistant. Otmar Thormann has worked as a freelance photographer since 1970. His work has appeared in numerous international photographic magazines including *Camera* and *Zoom*, and he has published three books: *Otmar Thormann* (1979), *Photographs – Variations* (1984), and *Otmar Thormann* (1987). His work has appeared in one-man shows in Sweden, Germany, France, Austria, and the United States, and in a number of group shows, including The Frozen Image: Scandinavian Photography (1982) at the Walker Art Center in Minneapolis, Minnesota. Otmar Thormann lives in Stockholm.

TOSCANI

Oliviero Toscani was born in Milan in 1942. He grew up in a photographic family; his father was a photographer, and his sister is still an interior photographer. After studying at an art school in Switzerland from

1961—65, Toscani, too, began working in the medium. Based in Milan, he concentrated first on reportage and later moved into fashion photography. His work has been published in all the major international fashion magazines, including French, British, and American *Elle*, and has won numerous international awards, among them the *Grand Prix d'Affichage*. His book *Vicenza Vicenza* was published in 1976. Oliviero Toscani refuses on principle to exhibit in galleries. He lives in Casale Marittimo, near Pisa, Italy.

PAUL WAKEFIELD
Paul Wakefield was born in Hong Kong in 1949. He attended schools in Hong Kong and England and later studied at the Bournemouth and Poole College of Art (1969) and the Birmingham College of Art (1970—72). Since 1972 he has been based in London and working as a freelance photographer. Since 1980 he has concentrated mainly on location advertising work. His photographs have been exhibited at Ffotogallery, Cardiff (1979) and the Photographers Gallery, London (1981). A collection of 100 of his colour photographs was purchased in 1984 by the Welsh Arts Council and has toured all over Wales. Paul Wakefield has published three books: *Wales: The First Place* (1982), *Britain* (1984), and *Scotland* (1986). He lives in London.

ALBERT WATSON
Albert Watson was born in Scotland in 1942 and received a degree in graphic design (1966) from Duncan of Jordanstone College of Art, Dundee. After travelling in the United States on a travelling scholarship from IBM, he went to London and received an MA in film and television from the Royal College of Art (1969). In 1970 he moved to Los Angeles, planning to work in films, but turned instead to still photography. Watson received his first assignment from the Max Factor company, with which he has had a long-standing association. During his time in Los Angeles, he worked as an advertising photographer and shot a number of album covers; one of them, for Warner Brothers, won a Grammy in 1973. From 1974 he travelled frequently to New York, working for *GQ, Mademoiselle*, and *Vogue*. He moved there in 1976 and has worked for major American and European magazines,

including *Stern, Rolling Stone*, and British and Italian *Vogue*. Albert Watson has received Andy awards for advertising photography and has exhibited his work in Canada and the United States. He lives in New York.

TODD WEBB
Todd Webb was born in 1905 in Detroit, Michigan. He studied photography under Ansel Adams at a workshop in Detroit in 1940 and served in the US Navy as a photographers mate from 1942—45. After the war he became a freelance photographer. He worked under Roy Stryker for the Standard Oil Company of New Jersey from 1947—49, and lived in Europe from 1949—54. From 1955—69 he worked as a photographer for the United Nations in New York. Todd Webb received Guggenheim Fellowships in 1955 and 1956, and a fellowship from the National Endowment for the Arts in 1979. His photographs have been exhibited widely in the United States and Europe and are owned by several public collections. Among his books are *Todd Webb: Photographs* (1965 and 1979) and *Georgia O'Keeffe: The Artist and her Landscape* (1984). Todd Webb lives in Maine.

BRETT WESTON
Brett Weston was born in California in 1911, the second son of the great American photographer Edward Weston. He left school at an early age and learned photography under his father's instruction. By the age of 16 he was working with his father in their California portrait studio and exhibiting his own work. During World War Two he served as a photographer in the Army, working in New York City, and in 1951—52 did the printing for a special portfolio of his father's images. He has pursued his personal work in photography for more than half a century and is especially renowned for his landscapes and studies of natural form. He has travelled extensively in the United States, Europe, and Japan; his work is held in many private and public collections and has been exhibited widely. He has published a number of portfolios and books, including *Brett Weston: Photographs* (1966) and *Brett Weston: Voyage of the Eye* (1975). His most recent books are *Personal Selection*

(1986) and *Photographs from Five Decades* (1981). He lives in California.

DE ZITTER
Harry De Zitter was born in Belgium. He studied at Port Elizabeth School of Art in South Africa and has been a professional photographer since 1971. He worked in South Africa until 1983, and then moved to New York. Since 1987 he has lived in London. Among the awards he has received is the *Ad Week* American Advertising Photographer of the Year award in 1987.

PUBLISHER'S ACKNOWLEDGMENTS

The publisher thanks the following photographers and organizations for their permission
to reproduce the photographs in this book:

12 © Art Kane 1987; 15 © David Burnett/Contact Press Images 1971; 17 © Bert Stern 1968; 18 © Clive Arrowsmith 1970; 21 © Edouard Boubat 1950; 23 © Frank Horvat 1958; 24 © Cornel Lucas 1959; 26 © Jeanloup Sieff 1977; 29 © Albert Watson 1979; 31 © Bob Carlos Clarke 1985; 32 © Wayne Miller 1950; 34 © Louise Dahl-Wolfe 1950; 37 © Hans Gedda 1981; 38 © Willy Ronis/Rapho 1949; 41 © Bert Hardy/BBC Hulton Picture Library 1948; 43 © Jane Bown 1974; 44 © Dawid 1987; 47 © Elliott Erwitt 1967; 49 © Angus McBean 1954; 51 © Jay Dusard 1981; 52 © Ralph Gibson 1987; 55 © Brett Weston 1987; 57 © Alfred Eisenstaedt 1934; 59 © Sally Soames 1978; 60 © Thurston Hopkins/BBC Hulton Picture Library 1955; 63 © Chad Hall 1965; 65 © William Klein 1982; 67 © Cornell Capa 1959; 68 © Todd Webb 1955; 71 © John Claridge 1986; 73 © Chris Smith 1984; 75 © Eva Rubinstein 1981; 77 © John Phillips 1951; 78 © John Loengard 1981; 81 © Toscani for Benetton; 83 © Otmar Thormann 1987; 85 © Horst 1988; 87 © Terry O'Neill 1988; 88 © Neal Slavin 1968; 91 © Yvonne Halsman 1988; 93 © Paul Wakefield 1985; 95 © Humphrey Spender 1937; 97 © Harry Benson 1968; 98 © Markéta Luskačová 1978; 101 © Robert Doisneau 1979; 102 © Herb Ritts 1986; 104 © Alan Brooking 1980; 107 © Arnold Newman 1978; 109 © Snowdon 1986; 110 © Norman Parkinson 1949; 113 © Ken Griffiths; 115 © Grace Robertson 1954; 116 © Andreas Heumann 1987; 119 © John Swannell 1985; 121 © René Burri 1960; 123 © Mary Ellen Mark 1987; 124 © Eamonn McCabe 1982; 127 © De Zitter 1987; 129 © Terence Donovan 1983; 131 © Barry Lategan 1980; 133 © Yousuf Karsh 1954.

AUTHOR'S ACKNOWLEDGMENTS

Thanks to the photographers
I would like to thank all the photographers who have taken part in this book.
It was a wonderful experience, and I hope you enjoyed it as much as I did.

I would also like to thank:
Keith Taylor for his patience and understanding,
for helping me throughout this entire project, and for making all the wonderful prints
of the photographers reproduced in this book.
Derek Harman, my agent, for all his guidance and encouragement and for being such a good friend.
Rodger Williams, Andy Henderson, Sara Taylor, and Piran Murphy for their kind assistance.
Bernie Nyman, my solicitor, and Lloyds Bank for being so supportive.
Eva Goodman, Fenella Stickland, Ilona Rich, and the Walkers for their warm hospitality.
Mum, Dad, Angie, Andy, Sonj, Chris, Mel, and Amy for putting up with me and for being so understanding.
Finally, to everyone else who has made this book possible.

All the portraits of the photographers in this book were taken on
Tri-X and Plus-X film generously supplied by Kodak.

INDEX